design &
composition
secrets of
professional
artists.

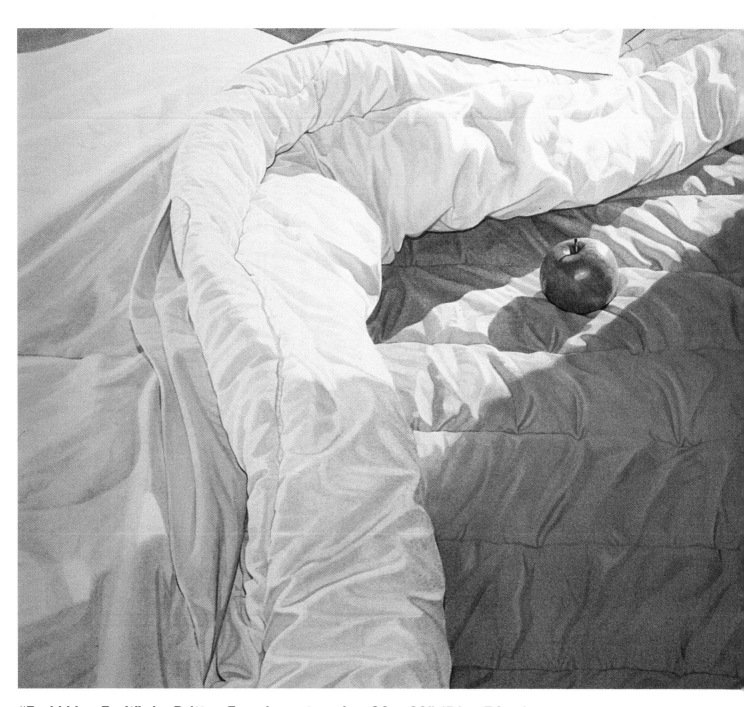

"Forbidden Fruit", by Britton Francis, watercolor, 20 x 29" (51 x 74cm)

design & composition secrets of professional artists.

16 successful painters show how they create prize-winning work

from the editors of International Artist magazine

International Artist Publishing, Inc
2775 Old Highway 40
P.O. Box 1450
Verdi, Nevada 89439

Design by Vincent Miller
Typeset by Ilse Holloway
and Cara Miller
Edited by Terri Dodd

ISBN 1-929834-09-8

Printed in Hong Kong
First printed in paperback 2001
05 04 03 02 01 5 4 3 2 1

Distributed to the trade and art markets in North America by:

North Light Books,
an imprint of F&W Publications, Inc.
1507 Dana Avenue
Cincinnati, OH 45207
(800) 289-0963

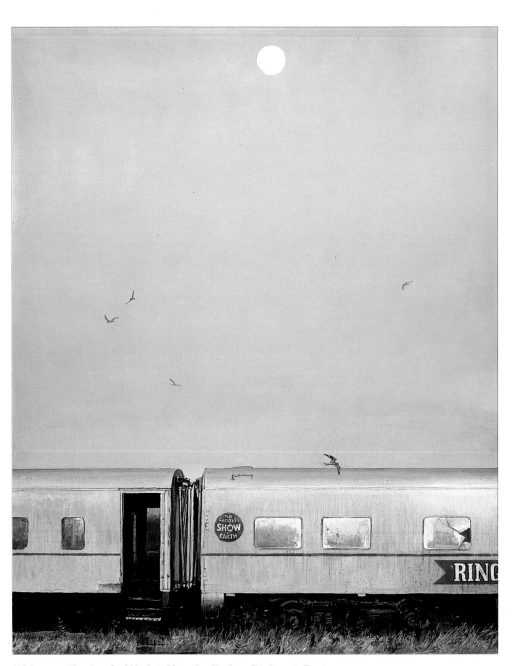

"Circus Train & Night Hawks", by Robert Bateman
36 x 28" (91 x 71cm)

acknowledgment

I would like to thank the 16 artists who, through the pages of this book, have so unselfishly given us access to their creative thought processes. The experience of being able to meet and work with such generous and talented individuals convinces me I chose the right job.

Vincent Miller
Editor-in-Chief/Publisher
International Artist magazine

preface

design will set your creativity free!

Design is really the idea behind the painting. It's how you translate your vision onto the canvas or paper. In this book, 16 highly successful artists show you their design plans, and you'll see that rather than having to stick to a set of rules, you can use any number of ideas.

You can choose to base your painting on shapes, like circles and triangles, or you can base it on contrasting or harmonious values, on color, texture and pattern. You can use a high horizon, or low horizon. You can work with light, space or even different formats. When you see how each artist in this book works you will realize just how many ways you can make your painting interesting. Working with design will set your creativity free, rather than inhibit it.

Thinking about the design of your painting first allows you to arrive at an idea and then pursue it, without losing direction. It is the ultimate cure for blank canvas syndrome because the ideas will just flow. You'll find you can go on to make 20 paintings from just one idea. You'll be more productive, and you'll be more satisfied with the results. And, what's more, when you bring a design plan to a successful conclusion, you know what you did to get there — so you can use the process again next time for a different subject.

Each artist in this book was asked to explain how they design their paintings, how they work and think. No other guidelines were imposed. Their essays give us an insight into the reasons why their paintings are so successful, whether they are realist or expressionist. You'll see a stunning mixture of many styles and approaches. There is design prompted by the abstract quality of shapes. A few artists follow their innate understanding of "rightness", their intuition and their sense of rhythm and harmony. Others take risks. One artist visualizes the finishing painting in his mind's eye first. Another harnesses the power of right and left brain thinking. One uses a studied approach. Another makes the Golden Section understandable. Several arrive at a great design by asking a series of checklist questions; one composes to enhance the viewer's emotional response. Two artists use underpaintings to suggest the painting's structure.

This book shows design from a refreshing new angle — where it becomes exciting and full of possibilities.

Jeane Duffey
Jeane Duffey is the Canadian Editor
of *International Artist* magazine.

contents

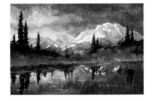

my composition strategy

I'll show you the design principles, the subtleties of composition, the philosophical approach and my checklists for making sure I am on track.

One of the most precious gifts we possess as artists is our imagination. From our imagination comes a multitude of ideas, patterns, shapes, and dreams, which allow us to interpret life's realities. The question we face in our artistic capacity is how to take these images and objects from our chaotic, active minds and place them onto a flat surface while giving them a semblance of order. Composition is the word used to describe this creative process. The study of composition is endless and requires knowledge of different techniques, materials, and sensibilities.

It is often hard to put our knowledge and experience on paper in order to share it. Our expressions are mostly hard won and manifest themselves in visual ways rather than orally. I rely heavily on a series of checklists designed to keep me in tune with my work from the moment I contemplate a piece to the time that I put down my brush. These lists are an invaluable tool constantly reminding me of composition and design in light of the subject matter I am trying to express.

Composition is a seamless integration of many different techniques and philosophies according to one's skill and approach to painting. Artists recognize that their individuality is built upon basic techniques or "building blocks". The following discussion, divided into four categories, includes these fundamental principles, a mixed media example, the subtleties of composition and a philosophical approach to art. They are, in combination, my current approach to composition and the creative process.

Design plans

✔ Make a checklist of your goals for each part of the process.

✔ Keep referring to your checklists to see if you are still on target.

fundamental principles of composition

SUBJECT

Before you pick up a pencil or brush you should ask yourself the following questions:

- What appeals to me about the subject I am going to represent?
- What emotion grabs me when I look at it and how can I express these feelings through my artwork?
- What part of the subject should be emphasized to maximize the impression I want to achieve?
- What colors and key best suit the mood I want to impart?
- What will identify this painting as clearly and uniquely my own and where am I, the artist, showing myself in this painting?

Every design decision should refer you back to your primary reason for doing the work. Creative decisions should reflect your initial response to the subject and introduce a personal quality.

SUBSTRUCTURE OR SKELETON

This is the bones of the painting and is always one of the first things I consider before I start work. At this stage you must decide on a format and choose the substructure which will convey the intended meaning most effectively.

The following diagrams are sample formats:

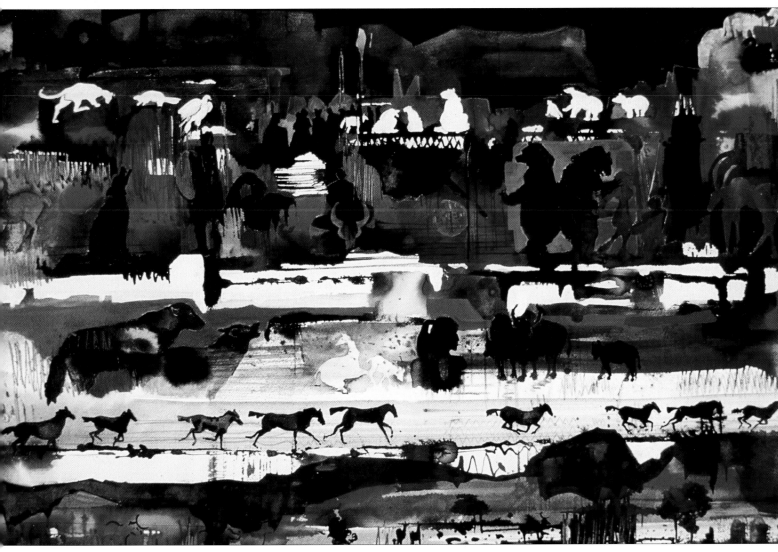

"Canadiana", mixed media, 22 x 30" (56 x76)

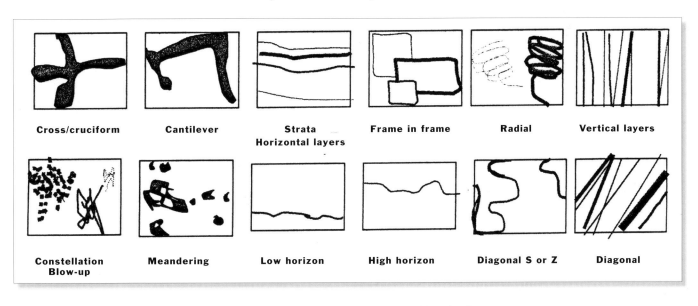

| Cross/cruciform | Cantilever | Strata Horizontal layers | Frame in frame | Radial | Vertical layers |
| Constellation Blow-up | Meandering | Low horizon | High horizon | Diagonal S or Z | Diagonal |

Formats — Horizontal or Vertical

Consider a structural foundation when you subdivide the area within your support. All subdivisions — both negative and positive — must be interesting shapes.

Avoid halves; do not divide your painting in the middle. Consider the whole picture plane by pushing the design one way or the other to create different areas of dominance. Create a variety of shapes, for example, think Mother, Father and Child shapes; this creates variety and avoids a static design.

"Facing Time", collage and mixed media

Take some time to look at good reproductions of paintings, photographs and advertisements that catch your eye. Rather than looking at the color or texture, focus on the underlying design format that holds the picture together.

You can also experiment with your subject using each of the design formats. Become familiar with their effect on different subjects.

FOCAL POINT

The focal point of a picture is the essence of your subject, it is the spot where you hope to interact with the viewer. When a focal point is placed too close to the edges or corners, the viewer's attention is led to the matboard and off to the next painting.

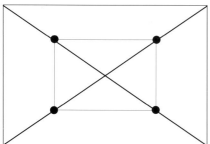

A simple way of finding focal "sweet spots" is to make an X from corner to corner with a pencil or chalk. Half way from the center to the corners, there are four places where a focal point sits well. The focal point should be placed where you intend to

have the greatest contrast, the most texture, the brightest colors, or the boldest variation.

Deciding on a focal point helps you to place texture, bold colors, interesting shapes and lights and darks where they will be the most effective. But there are no hard and fast rules in art. I have seen artists successfully place the focal point in the center of the painting with stunning results. My advice is to learn the rules first, then bend them to suit your artwork.

LEFTOVER SPACE

Remember that there is no such thing as "leftover space". Check to see if the objects you are depicting are interesting in height, width, depth, shape and size. Look at what is happening with all the space around those objects. Are they good shapes, both negatively and positively? Are the intervals between the objects unpredictable, or can you take a ruler and measure them to the exact inch? Viewers need surprises to keep them interested in your painting. Play with your own awareness remembering that even small shapes are important and that shapes within shapes are essential. If you have to choose between the reality of an object and good shape, choose a good shape every time. Also ensure that the negative shapes between the good shapes are interesting. Look at the number of shapes you have created and remember that paintings often fail because there are too many shapes rather than too few. Don't forget that you can interlock, adjust, reposition, relocate, enlarge, reduce, modify, or even eliminate shapes to make your composition work.

FOUR CORNERS AND EDGES

An artist never wants to be boring or anticipated. Try to be exciting even in the quieter passages. One way to accomplish this is to ensure that the four corners vary from each other.

While corners are not the most aesthetically pleasing place to put the brightest and boldest colors, they are important nonetheless. Ask yourself where your eye enters and leaves the painting? Often the eye enters from the lower left corner and moves from left to right. The area with the darkest dark and lightest light will attract the observer. If there are pointed shapes directing the eye out of the painting, always give them gradient values that are close to the surrounding values. This gives shapes a gentle, lost and found motion that takes the eye back into the painting. Determine where the positive shapes are hinged to the edges of the painting. If they are directly along the same line on both sides of the paper, adjust them to create a different visual "read", and produce more interesting negative space.

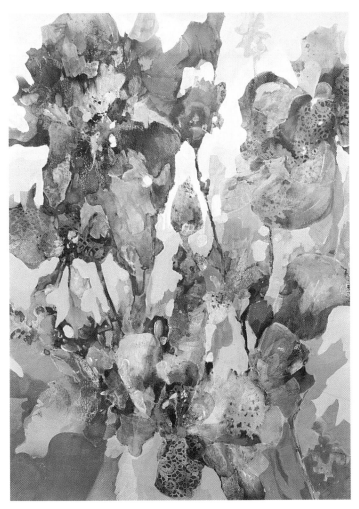

"**Flowers have a Refined Dignity**", mixed media, **30 x 22" (76 x 56cm)**

Before-You-Start-to-Design Checklist

- What is it about the subject that I like? What is the best way to express that?
- What would be the best understructure on which to place my subject?
- What rhythm do I want to use?
- What mood will I create for this theme? High, middle or low key?
- What shapes will work best — organic, geometric or linear?
- What would I like to be dominant and where will it be placed?
- Will I use a vertical or horizontal composition?
- What viewpoint is best suited for the subject — a close up, medium or far-off view?
- What colors are best suited to express my mood and what I want to say?
- How much depth will I require?
- How should I deal with the foreground, middleground and background?
- Where are the light and dark passages going to be throughout the painting?
- Will I need texture and, if so, will it be added during the process or at the very end?
- Is there a light source and how do I want to depict it?
- What personal qualities will I introduce?
- What will identify this painting clearly and uniquely as my own?

mixed media technique: the layering process

TEXTURIZING
Create surface texture with materials such as gel mediums, gesso or modeling paste. Use objects to imprint interesting textural effects into the modeling paste.

DEFINING STRUCTURE
The structural foundation, or skeleton, of the painting can be created using oil pastels, or five to six colored pencils in one hand to establish a tempo with curvilinear, geometric, oblique, horizontal or vertical lines. As you apply your lines, study how the negative spaces and positive shapes are strategically hinged to the edges of the paper. Think about the nature of lines and the

structural format that best conveys your feelings. This rhythmic structure will evolve into one of several formats.

When you subdivide the area within your support skeleton, consider the structural foundation. All subdivisions, both negative and positive, must consist of interesting shapes. Avoid halves and do not divide your painting in the middle. Consider the whole picture plane by pushing the design one way or the other creating different areas of dominance with a variety of shapes and sizes to avoid static designs.

ADDING DIMENSION
Dimension can be added using underpainted textures and

patterns. Place objects, such as porous fabrics, cheesecloth, feathers, facial tissue and plastic doilies, on the surface to act as templates. These elements may also be connected with more colored pencil lines. Spray or brush water over the entire surface to hold the objects in place and to soften any pigments. Try setting up a basic wash with a variety of yellows to provide a nice glowing undercolor, and then let it dry.

CHOOSING A PALETTE

Choose a "Queen Color" which will be the dominant color throughout the painting. If the work is highly textural, too many colors will pull the artwork in too many different directions. Analogous colors are the best choice, especially combined with a few complementary tones to provide accents.

Choose your colors and then mix large quantities to carry you through the painting. Be playful and let the colors intermingle. Think about using slow-moving opaque paints against fast-moving transparent pigments to produce interesting effects. Work fast and layer the colors.

"Italian Villa", mixed media, 20 x 25" (51 x 64cm)

LAYERING COLOR

Be continually conscious of the painting's design and structure. Over the first dry layer, add a second layer of color, placing negative and positive shapes at random intervals into the design. Let the layers of pigment mingle with each other. Be aware that you are creating a rhythm of light and dark passages.

While the paint is still wet, tip your board and let the colors move over the surface. 3-D objects often leave a lot of open white paper beneath them, so paint under each piece with a brush. If a white space appears afterward, you can sweep a glaze over the area without disturbing the underpainting.

TAKING TIME OUT

Know when to stop! Once you begin fiddling with little superfluous things, stop painting. Then, once it is dry, remove the various templates or stencils from the paper. If you don't know where you are going next in a painting, stop and think rather than paint until you see your way clear again.

MAPPING THE SUBJECT

At this point in the creative process your surface will be covered with exciting patterns, shapes and values. Use your imagination to find a subject out of the chaos. It might be anything, from figures and architectural elements, to floral or organic subjects. Use white chalk and go over the surface, searching out and highlighting objects without lifting off pigment. The chalk marks will provide a blueprint to continue with the picture.

"Symbols of a Traveler", mixed media, 30 x 22" (76 x 56cm)

SUBDUING AND ENHANCING

To de-emphasize areas that are less important use a gesso float (a watered-down application of gesso mixed with a color). These quiet shapes are important because they provide balance for the busy areas. Always begin with a light veil of gesso and then strengthen the degree of opacity depending on how subdued the area needs to be.

To enhance and accentuate the stronger portions of the painting, the parts you love, use a more concentrated pigment. Use brushes for both applications, working from big brushes down to small brushes to add variety in your strokes.

WEAVING IN DETAILS

See with fresh eyes — view your painting from across the room, upside down, or in a mirror. Note which areas in the painting need to be enhanced or refined. Think about combining color at random intervals, both horizontally and vertically. Picture a tapestry, and weave areas together without isolating areas of color.

Your aim is to let the painting rest predominantly on mid-tones with light areas to take the eye through the composition. Strategically place the negative shapes within the dark hues making them the richest colors. Gray down some areas by adding complementary hues.

CONFIRMING THE RESULTS

Look to see how you can improve the relationship between the paint and the design. Put the painting away for a few days, then come back and go through one last check. Use the "Reviewing Your Work Checklist". You may need to make some enhancements or adjustments to improve the piece and accentuate the relationship between the paint and the design. A few strong pure accents of soft or oil pastels, colored pencils and pen and ink provide the final icing on the cake.

Half-Way-Through Checklist

- [] Am I properly setting up to say what I need to say?
- [] What mood am I transcribing on this surface?
- [] Will the finished product be of a light, medium or somber disposition?
- [] Is there a place for a focal point?
- [] Are there too many shapes or are there too few?
- [] Is there an area demanding attention where it's not wanted?
- [] Are any parts so monotonous that they need strengthening?
- [] Is the work becoming too predictable?
- [] Do I need to add more symbols or texture with paint, pencils or pastel?
- [] Is there a dominant color?
- [] Is it half warm and half cool, and therefore in need of being pushed to one side or the other?
- [] Are there areas near the edges demanding too much attention?

"Crystal Mystique", mixed media

the subtleties of composition

TEMPERATURE AND THE FIFTY/FIFTY FACTOR

Something that I discovered at art school was what I call the fifty/fifty factor. It seemed that paintings that were really dreadful received attention as well as the paintings that were exceptionally skillful. The ones that were simply "nice" just didn't seem to be noticed at all. I have since taken this theory further and applied it to design principles.

When a painting has a temperature problem, I can usually trace it to the fifty/fifty factor. In other words, the color is half cool and half warm so that the different temperatures fight for dominance or attention. At this point, I make a decision to either push the piece cooler or warmer so that it has a temperature dominance which will produce a much stronger work of art. This can be accomplished by clear glazes, gesso floats and translucent or opaque passages over large areas.

TEXTURE

Texture can occur before you put brush to paper, it can be added during the process, or as the final step of the painting. There are unlimited ways of creating texture, such as thin or thick layers of gesso or gel, oil pastel, crayon, wax, colored pencil, collage, printmaking, porous fabric, and stamping just to name a few. Where you put these materials is critical because, for the most part, once applied they are there to stay. Work the entire

design. This is called "displacement". In other words, place texture throughout the painting in different sizes and at different intervals so it is not isolated. The eye will be attracted to the textured areas. As an artist, you should guide your viewer through the painting. The general rule is to use less not more. Texture can look "kitsch" if overused, but incredibly rich if executed with good design skills.

RHYTHM

Use the tempo that best expresses how you feel. Curvilinear rhythm, for example, can be an excellent method of depicting a reclining figure, flowers, or a restful landscape because wavy rhythms tend to create feelings of calm, quiet tranquility.

Use the paper horizontally to enhance the movement. Wave-like brushwork can accentuate rhythm while keeping the viewer interested. Any painting surface needs quiet areas juxtaposed beside busy areas. This can be accomplished by using strong color or restful rich grays, while handling the area with a less amplified rhythm. As long as the dominating rhythm is of one style it will create unity. For relief and disparity put in another contrasting rhythm, in smaller quantity, to attract the viewer's eye.

Different rhythms deliver different messages:

Vertical rhythm suggests majesty, dignity and growth. Use the paper and brushstrokes vertically if you want to heighten your message. When the painting requires drama, excitement, imbalance, tension and uneasiness, attempt a diagonal rhythm to convey the message enhancing the drama with oblique brushwork.

Often a **triangular organization** reflects a sense of spirituality, especially if the triangle is pointing upward which accentuates the larger, stable base on which the shape rests. On the other hand reversing the triangle so its base is standing on a triangular point can cause tension and uneasiness. Always be mindful of which rhythm best expresses your purpose.

Circular compositions are tricky, especially when it comes to producing stimulating negative

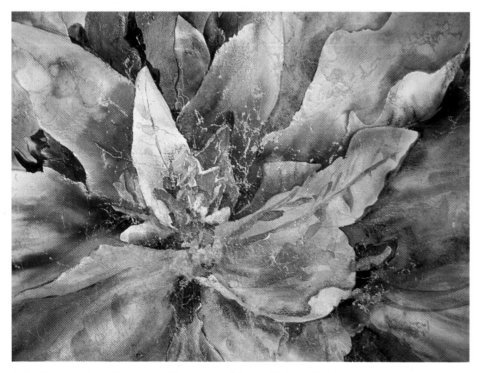

"Radiance", mixed media, 30 x 38" (76 x 97cm)

shapes. You must be mindful of this problem when executing spherical forms. Circular strokes can push your painting psychologically; they can accent a point, or direct the eye.

Rectangles seem to lend an air of solidity giving the viewer a sense of comfort. Rectangles and other geometric shapes also lend themselves to expressive brushwork. You can create motion and emotion by using specific shapes.

Remember that too much repetition can destroy any design. One way to relieve this is to add curved, circular, cylindrical or triangular accents. You can also use shapes to lead the viewer's eye.

Exaggerating rhythm can create a range of moods from playfulness to uneasiness depending whether the strokes are gentle and soft, in or out of alignment, or executed in wide, thin, or agitated lines. With so many variables it is important to recognize which mood the rhythm sets up in your painting. It is important to continually feel the mood with your intellect and your emotions. Let the atmosphere you are creating on your surface be your guide.

COLOR AND KEY

The mood of your work can be set by the values and colors you choose. For instance, a busy composition usually calls for an analogous color scheme allowing the similar tones to provide compatibility. Light and airy compositions can be enhanced with tints of pastel color. To set a contemplative mood use colors and tones of darker value, adding a small portion of light to entice the viewer.

LINE

From strong contour drawings to quick gestures, line can convey messages, set tones, provide continuity and be the basis of an honest and forthright design. An artist can fudge and rearrange shapes, colors, pattern, proportion and many other components but lines seem to stand alone with integrity. An art teacher of mine once said, "Drawing is from the intellect and color is from the emotion". Whether this is true or not, line can be a very beautiful and expressive tool. Choose from thick, thin, rough, smooth, broken, repeated, lost, found, striped, solid, horizontal, vertical, diagonal, circular, striped, straight, crosshatched, directional, overlapped, zig zag, rhythmic, fast, slow, contoured, single-action strokes or double-action strokes, nervous, calm, scribbled and many other types of line.

Line is also a tool with which to direct the viewer.

What -Do-I-Need-to-Change? Checklist

- Are there too many or too few shapes?
- Does it need a line to lead the eye into the painting?
- Do the edges have variety and are they interesting?
- Does the work have a color dominance?
- Does it have a temperature dominance of mostly warm or cool?
- Are the negative shapes varied?
- Is the structuring design still obvious?
- Are the accents and quiet areas harmonious?
- Are there bulls-eye darks or popping out whites that distract needlessly?
- Is the entire surface part of the whole design?
- Have I done everything possible to express the one thing I set out to express at the beginning?

The use of lost and found, and thick and thin movements can gently lead the onlooker in the intended direction. Most importantly, line can serve as the final cohesiveness bringing all the components of the work together and making it a whole.

One of my mentors said that the spirit of creativity comes through the line into the painting. Moving through the painting it always exits gracefully so that the original creative spirit may continue to flow into the universe and into other works of art. I like this kind of poetic thinking.

EXAGGERATION

Exaggeration can be an exciting dimension in painting but it can also be very difficult to know where to use it. The simple answer is to exaggerate the part of the subject you find particularly fascinating. If the hands in a figurative piece interest you, try overstating them and subduing the other compositional elements.

BEWARE BULLS-EYES AND POPPING WHITES

Squinting allows the artist to notice unwanted dark areas that will have the effect of black holes or bulls-eyes and attract unwanted attention. These spots can be very distracting, but can be remedied by lifting pigment with

a clean cloth and water, rubbing alcohol, or turpentine as necessary.

Another method for distilling these areas is to apply a glaze or a light tinted, opaque float over the area. Black holes or bulls-eyes can also be reduced by simply bringing the adjacent colors into closer tonal proximity using mid tones rather than sharp contrasts between light and dark. If you are using collage in the artwork, the solution may be as simple as applying a transparent piece of rice paper to lighten the area.

Whites can be seen clearly when the eyes are opened wide. "Popping whites" are bothersome when the viewer is being agitated pointlessly. Gradate white colors out to the edges from the focal point so the white still appears as a very light value with a hint of a glaze. If the light and dark values are too far apart try a glaze half way between the two colors and apply it so that it overlaps neighbouring pigments bringing the values and colors closer together. Think of the glaze as a stepping stone for the eye.

MIXING INCREDIBLE DARKS

Just as one musical tone played repetitively is monotonous so is using the same dark color throughout the painting. A large range of beautiful darks can add maturity and depth to your work. Use them generously, experimenting with different tones.

MIXING SUMPTUOUS GRAYS

There are so many wonderful tints of gray color to provide beautiful passages that properly treated paintings can actually croon. Gray is such a versatile color that when it is placed strategically around busy areas it can become either warm or cool, depending on the temperature of the painting.

Get to know your grays by rendering an entire work in different gray mixtures adding only a small area of bright color as a focal point. Spend time with the paint and palette mixing a myriad of different gray tones. I think you will find it a truly revealing exercise.

the philosophical approach

KNOW THE PRINCIPLES

Spend time learning the foundations of drawing, color theory, values, unity and design. Learn as much as you can. If you cover the basics you are quicker to grasp new information and concepts. The more you know and the more you practice the better your intuitive skills and expressions become, and the greater your ability to express creative originality.

FLEXIBILITY

More often than not, the original idea I have about what I want to paint will change during the actual process. This can more accurately be described as an evolution whereby the work is altered dynamically as the creative process takes place. While dictating the rules of composition may seem to go against this more dynamic method of creating, it is important to have a continuous dialogue with the work, and knowing the rules of composition simply means that the dialogue is more informed. If there is something wonderful happening in the paint, stay open to that and work with it rather than against it. Stay flexible to the adventure of creativity with the correct balance of emotional spontaneity and intellectual consideration.

INCREASE YOUR MATERIAL VOCABULARY

It is also important to stay on the growing edge of the art materials market keeping informed about new products. Learn as many mediums, for example, oil, pastel, acrylic, watercolor, conté, pen and ink, collage, so you leave no rock unturned. That way you provide yourself with expressive options. Being familiar with art materials and what you can do technically, will only heighten your ability to express emotion. Practice and take risks, because learning the language of art and building a sufficient vocabulary with which to communicate, leads to growth as an artist. If you keep following your own footprints, you will end up where you began, but if you stretch yourself your artwork will flourish.

PUSH THROUGH THE BLOCKS

Some artists seem to collect piles of unfinished paintings. These are usually works that have stumped them in some way. Place these pieces around the room and examine them for a common pattern. Often we take the path of least resistance, and instead of dealing with the problem we move on to the next sheet of paper and back to our comfort zone. Every block is a learning experience that must be mastered. These unfinished works are actually a gift because they tell us directly what we need to learn

as artists to grow and improve. Resolve your blocks! The next time you come to the same block your knowledge and experience will allow you to move on. By consistently working your way through each piece the perception of blocks will drop away.

Collect ideas from everywhere. Build files for different objects, seasons, feelings, ideas and fill them with samples and examples. Without plagiarizing anyone else's work or composition we can creatively borrow ideas and data from a multitude of sources. All artists occasionally find themselves at a creative loss, and we all need inspiration.

ZEN

Believe you are actually touching what you are painting. Become one with the subject. If you are painting a rock, believe your hand and brush are going over the surface as you paint. This oneness creates credibility and integrity. Use your memories and the sense of your mind to touch, feel, smell, and see your subject.

TRUST YOURSELF

One of the toughest hurdles is to believe in yourself enough to break your own trail. To be the final judge of your work and to trust yourself creatively is an accomplishment. Painting for the acceptance and approval of others comes at a high price. Ultimately you will lose the power to determine you own sense of being. Look to yourself and trust in yourself.

Don't be afraid to venture away from the mainstream to find your way. I have noticed in my own life that some people want me to remain the same. I suppose there is some comfort in that, but if I listen to their advice I will only end up where I began. Only by taking risks can one develop fully as an artist.

Having enough confidence to trust yourself takes courage, but, ultimately you will be rewarded. The final word goes to Mary Cassatt, who said, "Acceptance by someone else's standards is worse than rejection".

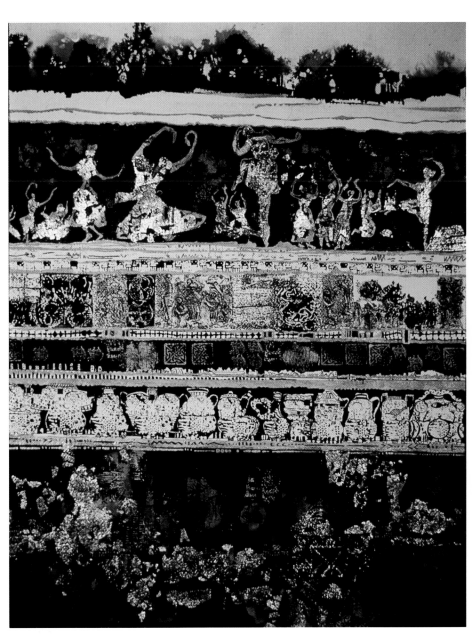

"Celebration to the Earth", mixed media, 30 x 22" (76 x 56cm)

about the artist

Donna Baspaly studied privately in Canada at the Kwantlan and Langara Colleges in the Fine Arts Program. She has been exhibiting publicly since 1979 and her work has received several awards in juried shows. She has had many solo exhibitions.

Donna has had several prestigious commercial commissions and her lithographs and cards are distributed internationally by Canadian Art Prints.

She was a judge for the Pacific Western Airlines and United Nations Childrens' Art contents during Expo 86. She acts as a juror for the Pacific Rim International Miniature Art Contest and has juried shows at the Federation of Canadian Artists. She was elected to signature status by the FAC in 1997.

She has participated in many group exhibitions with the Canadian International Festival for the Arts. She also collaborated with Canadian Airlines to help raise money for AIDS research in an exhibition at the Vancouver Art Gallery.

Her work is in many private and corporate collections in Canada and internationally.

robert**bateman**

I look for the abstract quality

My compositions have no rules and regulations, they are absolutely intuitive, just whatever comes into my mind. They are inspired by different sources — movies, great photographs, even mundane photographs. I go to museums and look at the work of other artists, representational or abstract — ideas come from everywhere and they don't follow any rhyme or reason.

When I compose, it is the abstract quality in the subject that attracts me. Before I start to paint I work out the composition in thumbnail sketches and small doodles. If the abstract quality is there, it will work in the thumbnail. This abstract quality is something totally intuitive; I know a design works when the eye moves around the format instead of becoming focused in one place.

However, I can think of two paintings with abstract compositions that are the exact opposites of each other. One composition ranges all over the canvas like an octopus; the other has its focal point right in the centre of the top third of the painting. As abstract shapes they both work. (Turn to page 21.)

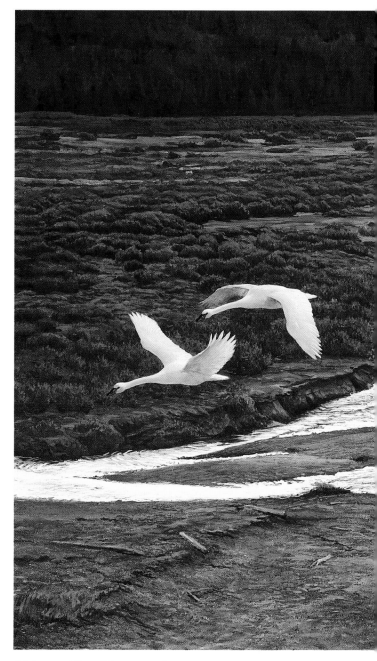

"Above The River — Trumpeter Swans"

Design plans

✔ When I compose I always look for the abstract quality first.

✔ I break rules on purpose.

✔ I use cut-outs to help me place major elements.

ABSTRACT
This diagram shows the abstract quality of the composition. The high tree line, and a swoosh of waterway reminiscent of Japanese brushwork, are balanced by the triangles represented by the swans.

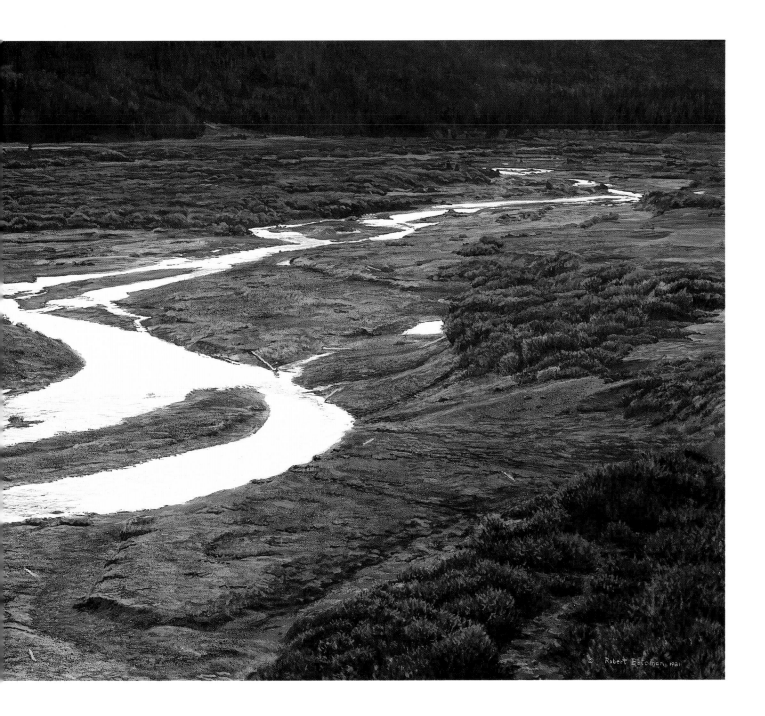

VALUE PLAN
Here is the tonal value map of the painting. You can clearly see how the dark, light and mid value plan enhances the composition by leading the eye to the focal area.

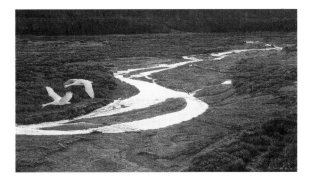

MONO
Without a horizon or light sky this painting relies on the perfect shape of the lightest light of the river to give it contrast and balance. The painting also meets other design parameters of gradation, harmony and unity.

my cut-out composition tactic

A thumbnail of the abstract design
This abstract shape has a pleasing sense of "rightness".

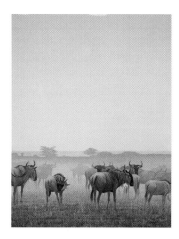

The missing element
Here's how the scene looks without the sun. All the attention is in the foreground. This painting needs an element of balance.

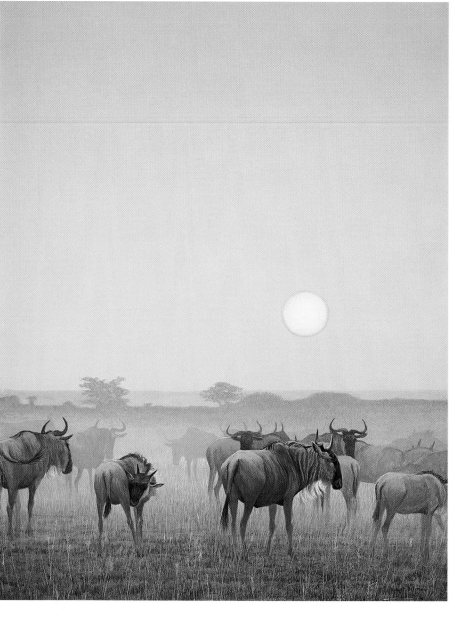

THINKING IN THE ABSTRACT

Most people have an innate sense of composition that they can't explain. It just looks right. This cut-out-and-place exercise confirms that instinct.

I roughed the landscape in first using acrylics. Then, on a separate piece of thin Bristol board or heavy paper, I made little paintings of the sun. I cut the discs out, put bits of masking tape on the back, then I lightly stuck it on the painting where I thought it would look good. I can't really tell until I try it, and if it doesn't work, I move the cut-out around a little bit. Big, small, high, low, left, right.

The cut-out idea works for most subjects — animals, barns, trees, birds. Instead of cut-outs you can use sheets of acetate that you overlay onto the painting.

I usually stand by the mirror while I am going through the cut-out exercise, because when you see the composition in reverse you can see immediately if there's a problem with the picture.

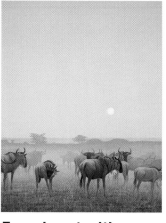

Experiment with cut-outs
First, I tried a small cut-out sun.

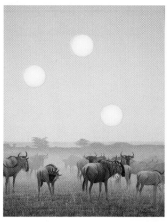

Moving cut-outs around
I tried the cut-outs in different positions, until I decided the one that felt right.

two different abstract compositions

Don't linit yourself to using the same composition every time.

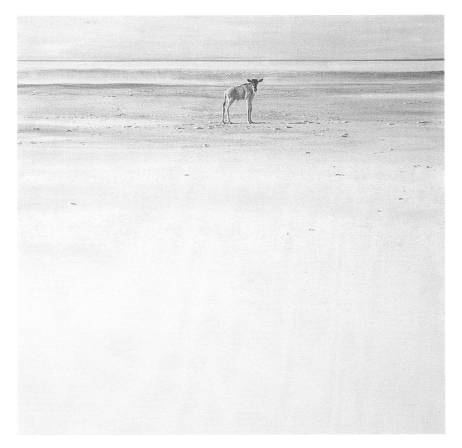

DESIGN TACTIC

**"Lost", acrylic on canvas,
3 x 3' (91 x 91cm)**

In this composition there is an empty, white, dried-up lake bed and absolutely centered a little way down from the very high horizon line, a tiny little young wildebeest stands there very, very alone, with just emptiness all around it — right in the center.

The very high horizon was inspired by Wyeth, and was placed one-eighth of the way down from the top of the canvas.

Notice that any definition present in this almost monotone landscape is near the subject. The foreground is almost non-existent, drawing the eye up to the lost wildebeest. All the space around the little animal emphasizes its predicament.

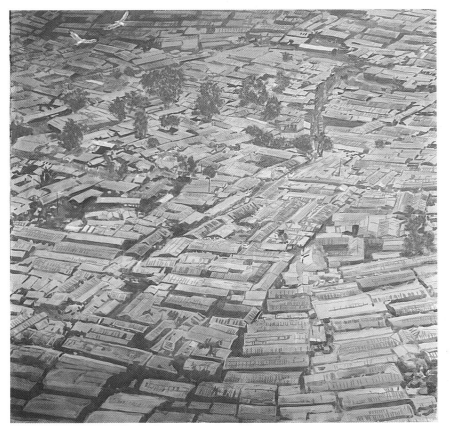

DESIGN TACTIC

**"Growth", acrylic on canvas,
3 x 3' (91 x 91cm)**

In this painting there is no horizon line at all. It is an aerial view of Nairobi. The imagery is quite lovely — the rhythmic little streets and laneways, roofs, tin shacks, sheds, rusty or not. Overhead a couple of vultures circle, but they are small and unimportant.

Again, Africa's dusty atmosphere mutes the colour into an almost monotone painting. All the lines are soft and there is hardly any contrast.

The abstract reduces this sprawling town to a mass of shapes gently radiating out from the area containing the few remaining trees. The shapes overlap, and although sizes vary a little, you will notice there is not one dominant shape or value. The vultures are placed in the top left corner. I used my cut-out approach to find the "right" position according to my compositional instinct. The vultures are the lightest value objects in a painting which has none of the surface tension of the wildebeest work.

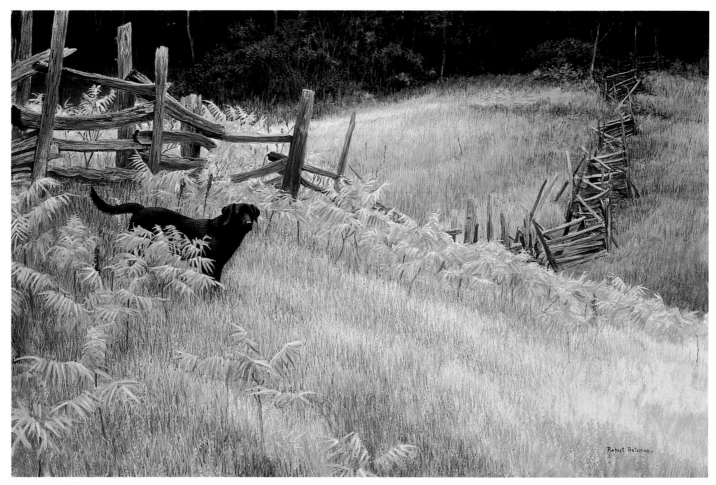

"Smallwood"

VALUE PLAN

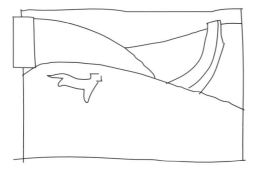

ABSTRACT
The inverted v-shape of the foliage points to the focal point of the dog all on the left of the painting. Note how the foreshortening of the fenceline accentuates the slopes in the terrain.

making the composition almost perfect — but not quite

I have never been one who subscribes to a formula. I have one rule, and that is I try not to divide the picture into equal halves with a horizontal line, like a horizon, or a vertical tree-line going through it, absolutely dividing it into two equal parts.

Having said that, I have occasionally broken that rule on purpose because I don't wish to have rules and be shut in a box. The only other consideration I take into account is the "dynamic point", which is the only thing I have ever remembered from a course on composition at summer art college.

A lot of artists use these rules — diagonals, dynamic points and so on, and I think that the Renaissance artists used them too. So occasionally, I'll find the dynamic point and move something off a little bit — ending up with a composition that is perhaps a little disturbing, almost perfect, but not quite.

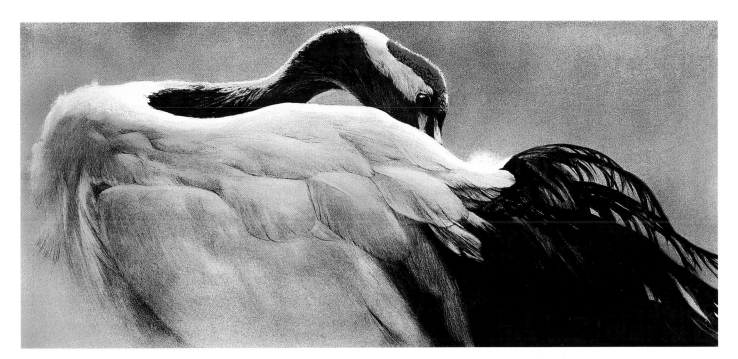

"Ceremonial Rose — Red-Crowned Crane", 15³/₄ x 33⁷/₈ (40 x 86cm)

This was an original lithograph printed in 7 colors.

VALUE PLAN

This painting has a perfectly balanced value pattern of darks, medium and light tones.

"Haida Spirit"

ABSTRACT

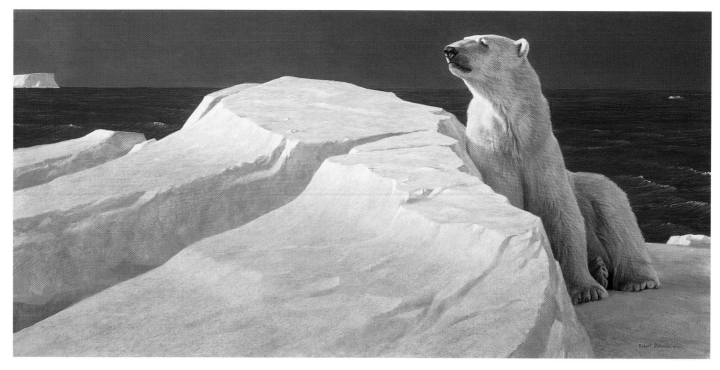

"Long Light — Polar Bear", acrylic, 10½ x 21¼" (27 x 54cm)
This painting tells a story. Sheltered in the lee of a large chunk of ice, the polar bear, with lazy, half-closed eyes lifts his head to sniff the air. The long zig-zag crack in the ice leads the eye to the bear.

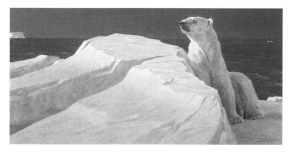

VALUE PLAN

ABSTRACT

my composition turning point

Early in my career I was working directly in the field. I tramped around like the Group of Seven with my sketchbook looking for a tree rhythm going this way and a counter-rhythm going that way and s-shapes, and things one looks for, and then I just sat down and did my version of it.

Generally speaking, a quarter to a third was sky, and the main subject matter occupied the middle half. Then the bottom quarter was foreground leading up to it, with a certain kind of perspective and point of view and scale. I have some classic examples of that period and they are not as sophisticated in composition compared to my present ones.

When I saw Andrew Wyeth's exhibition in 1962, it was my road to Damascus. When I saw his work "Trodden Weed", in particular, I realized there was a whole new way of composing. In "Trodden Weed", the horizon was literally a sliver. Many of the things I saw I had never thought of, such as diminishing the horizon. I'd barely thought of doing landscapes of close-up things without a horizon. I found that whole point of view refreshing and liberating.

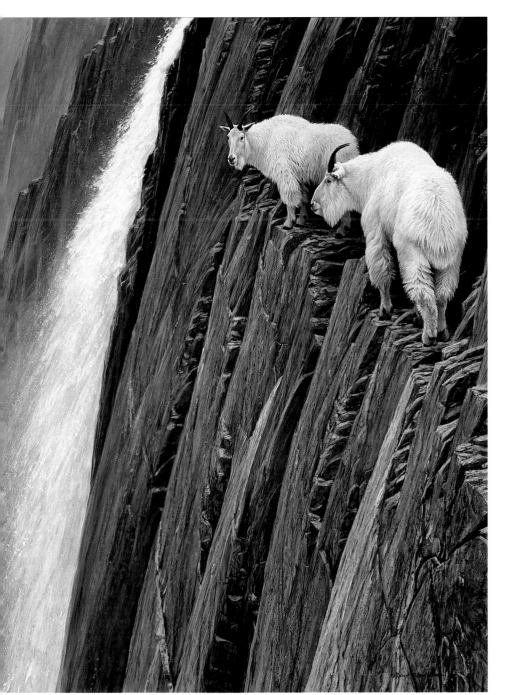

**"Sheer Drop —
Mountain Goats"**
This composition is about tension and drama. The dramatic lines of the cliff and waterfall are intersected by the upward diagonal path on which the two goats are clinging. The path appears to have run out. What will these creatures do next?
 Notice how the goat shapes overlap.

ABSTRACT

"I know that a design works when the eye moves around the format instead of becoming focused in one place."

"Red-Winged Blackbird and rail fence"

This is a statement about light and dark. What a great abstract this makes in its own right. Bold diagonals, balanced with delicate verticals. The mono version shows how the dark shape of the blackbird is placed in the lightest area to attract the eye. It is a rule of nature that the eye is always attracted to the light first.

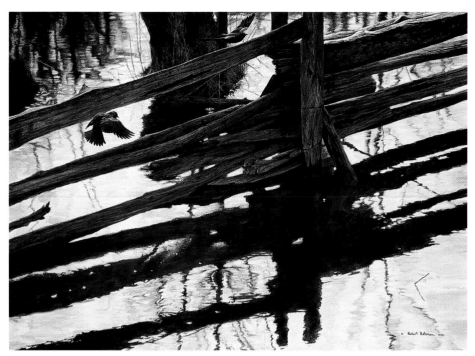

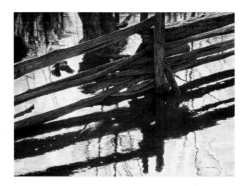

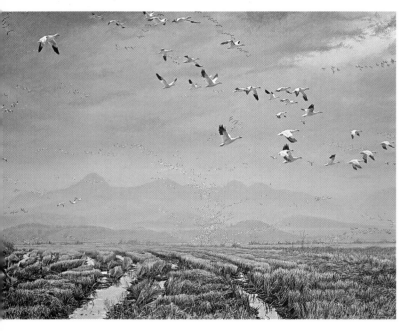

"Across the Sky"

A very strong horizon is established at the bottom of the picture. The main point of this painting is the aerial perspective which is achieved by the diminishing skeins of geese and by the atmospheric handling of the mountains. You can feel the spatial qualities of the landscape over which the foreground geese are flying.

At the same time I was gravitating towards realism. I was watching very beautiful and sophisticated European and British films in which the cinematography was absolutely brilliant. Those film-makers had imagination, and I'm sure that had a liberating effect on me too as I saw the possibilities.

"Lawrence of Arabia" and "The English Patient", spring to mind as just two examples of movies that have had an impact on me. From a composition point of view, movies like these are often more interesting than 90 per cent of the paintings I see.

I rather pride myself on being a creative photographer, in other words, I am an artist in my photography and consciously make creative compositions. Many of these photographs wind up as the landscapes in my paintings.

As a result of all of this, my work today is more interesting and unusual and it is generally inspired by the landscape rather than the subject. I usually try to include some kind of wildlife in my paintings, although I have done some that are simply habitat.

When I embarked on realism my composition became interesting. Earlier on in my career I had tried to make my pictures interesting through the use of color and paint.

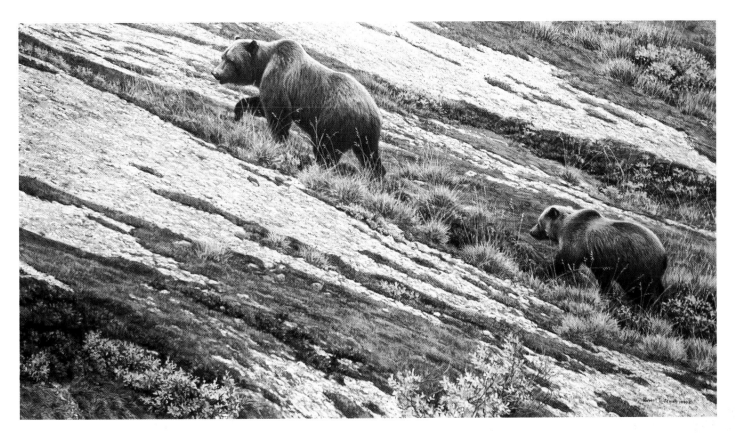

"Alaskan Autumn", acrylic, 24 x 42" (61 x 107cm)
Here's another story. The mother bear and her thriving cub roam the
hills looking for food in the time of plenty before they must hibernate
for the winter. Harmonious colors support the peaceful atmosphere
of this story. A strong diagonal theme and placement of shapes and
color give the picture balance.

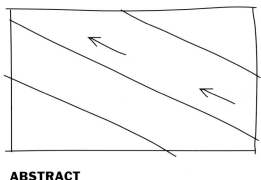

ABSTRACT

about the artist

70 year-old Robert Bateman has been a keen artist and naturalist from his
early days. He has always painted wildlife and nature, beginning with a
representational style, moving through impressionism and cubism to abstract
expressionism and, in his early 30s back to realism again.

Robert has been accorded greater honors than any other living Canadian
artist. He is an officer of the Order of Canada (the country's highest civilian
award). He was awarded the Golden Plate from the American Academy of
Achievement, and has been named one of the 20th Century's Champions
of Conservation by the US National Audubon Society. He has also been the
subject of several films. Three books of his art have made publishing history,
having sold more than 750,000 copies. Two others have been widely
acclaimed. A public school in Ottawa and a secondary school in the Fraser
Valley are named after him.

Robert Bateman was born in Toronto, and he has a degree in geography
from the University of Toronto. He taught high school for 20 years, including
two years in Nigeria. He traveled around the world in a Land Rover in
1957/58, increasing his appreciation of cultural and natural heritage. Since

leaving teaching in 1976 to paint full-time, he has traveled widely with
his artist/conservationist wife, Birgit, to many remote natural areas.

His work is held in many public and private collections and several art
museums. The Governor-General of Canada commissioned him to create a
painting as a wedding gift to HRH Prince Charles from the people of Canada.
His work is also represented in the collection of HRH Prince Philip, the late
Princess Grace of Monaco and Prince Bernhard of the Netherlands.

His art reflects his commitment to ecology and preservation. Since the
early 60s, he has been an active member of naturalist and conservation
organizations on a global scale. He has become a spokesman for many
environmental and preservation issues and has used his artwork and limited
edition prints in fund-raising efforts that have provided millions of dollars for
these worthy causes. He says, "I can't conceive of anything being more varied
and rich and handsome that the planet Earth. And its crowning beauty is the
natural world. I want to soak it up, to understand it as well as I can, and to
absorb it. And then I'd like to put everything I have absorbed together and
express it in my paintings. This is the way I want to dedicate my life."

alessandra bitelli

let me suggest new possibilities

Developing a composition is a creative process involving intuition and thinking more than following rules. It is a continuous flow of ideas, where the artist combines, adds, reduces, adapts and discards the various elements in an unending discovery of new possibilities.

The first step in becoming a painter is learning the technical elements of painting, that is, the use of the mediums and the basic knowledge of drawing, perspective, anatomy and color theory. These tools can be acquired through workshops and courses and by studying nature.

Understanding composition and design is the second step. This deals with the aesthetic elements of picture building: shapes, lines, colors, values, volumes and space. These must be organized in a coherent and harmonious arrangement in order to achieve a well-balanced and interesting composition.

Following some basic principles of composition and design is probably a good thing. However, in my opinion it is unwise to assert absolute rules. Through composition, the artist can emphasize the idea behind the subject while spontaneously expressing your own aesthetic vision, free from following the rules or breaking them. In fact, composition, design and content are the basic creative qualities of a painting, the ones that reveal the personality of the artist.

Design plans

✔ Search for balance, solidity, dignity and harmony.

✔ Use space, shapes, values and volumes.

✔ Work with economy, moderation and simplicity.

"November", acrylics and egg tempera on illustration board, 15 x 15" (38 x 38cm)
The significance of this painting goes back to Italy to the religious feast of All Saints, which takes place on the first day of November, followed by a day of remembrance of the dead on November 2. Mums, the large puffy ones, are the traditional and seasonal flowers for the celebration.

My visual idea was of puffy white mums in a basically black and white composition.

After making my value sketches, I chose my colors, black, white, Magenta, Cobalt Blue and Light Yellow to achieve colored blacks and colored whites, which I hoped would give me an extreme, though sophisticated, simplicity. I used acrylic and egg tempera paints on illustration board, playing with both brush and palette knife.

The strong division of the space, the carefully related round and straight forms, and the extreme reduction of details, create an interesting and powerful composition, and still maintain a good balance between abstraction and reality to successfully convey the original idea.

VALUE SKETCHES

The first value sketch for this painting was very simple: two black shapes enclosing a white one, with a slight diagonal direction.

In the second sketch I placed the two vases with mums, modifying and enlarging the white area, but preserving the original direction of the lines, for illusion of depth.

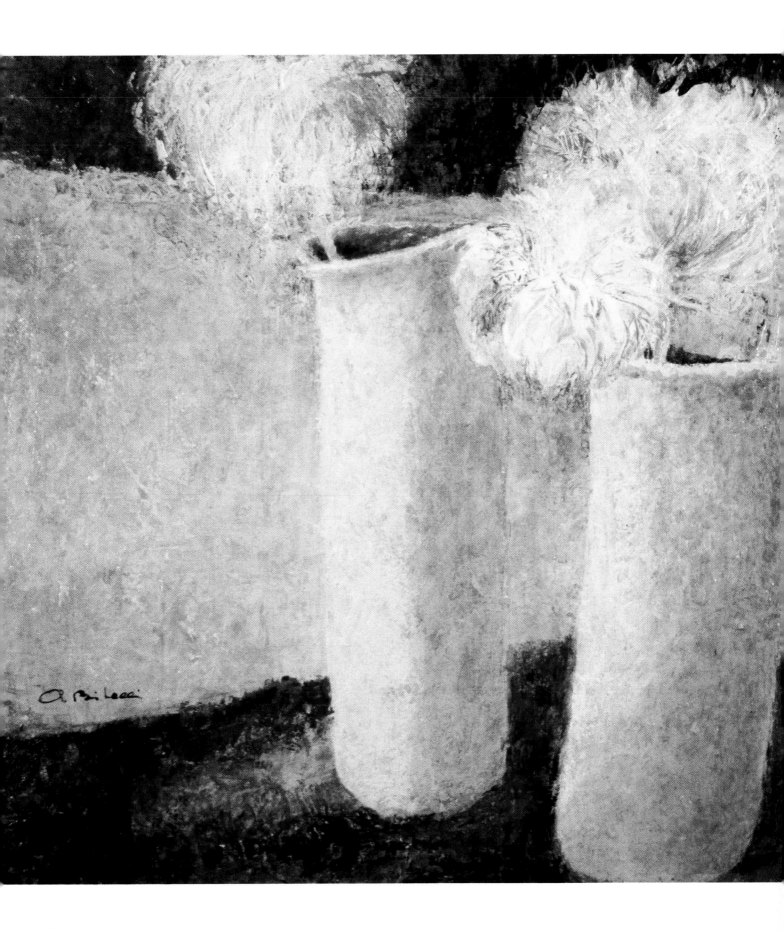

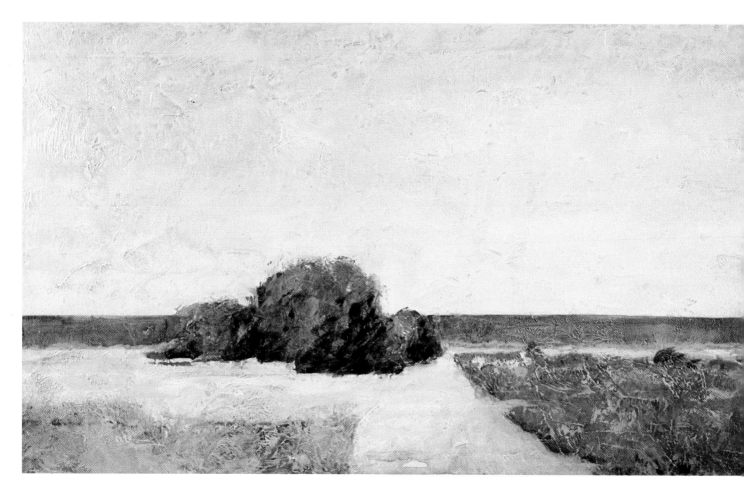

ABSTRACTION AND REALITY

During the growing process, every artist starts to rely primarily on some of the aesthetic elements of composition, the ones that better express their personality. Some artists also create a sort of formula on which to base their composition. I suggest you practice abstract combinations of aesthetic elements to create compositions both in black and white and color, until your personal tendencies begin to emerge and indicate the path to be developed.

Over the years, I have realized that my tendency is toward quiet, still, simple subjects, expressing my quest for balance, solidity, dignity and harmony. In composition I have found that space, shapes, values and volumes are the elements that better help me to express my personality. I have also developed a painting process that helps me to strengthen the basic structure of the image.

MY PROCESS

Having chosen my subject, the first step in my creative process is finding a suitable division of the space in terms of values.

I make a number of very quick black and white small sketches, often as simple as only two shapes of different size. Then I accommodate my objects in the chosen

"Sandy Beach", acrylics on illustration board, 13 x 26" (33 x 66cm)

This is a horizontal painting with a very low horizon line and a very shortened foreground.

I used acrylic paints on board and the following colors, black, white, Cadmium Yellow Light, French Ultramarine Blue, Magenta and Cobalt Blue.

I focused on obtaining a sense of both reality and imagination, with extreme economy of means with only a few details in the far away bush, that I enlarged over the original shape.

Through severe simplicity this painting has a strong illusion of depth and conveys the light and the stillness of a deserted beach.

VALUE SKETCHES

The first sketch was just a dark horizontal stripe, dividing the entire surface into two light shapes, the top one much larger than the bottom one.

Then I added three smaller dark shapes in the bottom area, slanting them toward the center of the composition.

"Yellow Flowers", acrylics, 20 x 20" (51 x 51cm)

This painting represents an effort to combine a composition with round shapes, conveying a feeling of weight and solidity, using two round vases from my shelf as models.

Having divided the space into basic value shapes, I introduced two vases, the darker one in the dark space, and the lighter one in the light space, allowing some minor variations to take place.

The chosen colors were black, white, Cadmium Yellow, Red Oxide, French Ultramarine Blue.

I really enjoyed playing darks on dark and lights on light with warm colors, and suggesting round lines to complement the round shapes of the vases.

At the end, I added a piece of a third dark vase in the right lower corner, definitely breaking the rules and strengthening the overall structure of the painting.

I think the result is a well balanced composition, where the eye is smoothly guided across the painting to the focal point of interest.

VALUE SKETCHES

 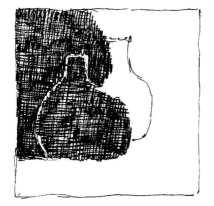

First a division of shape.

Then an introduction of elements — a dark vase in the dark space and a light vase in the light space.

VALUE SKETCHES

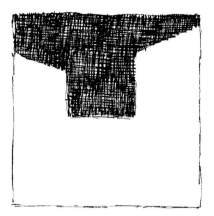

My value division of the space shown as two shapes.

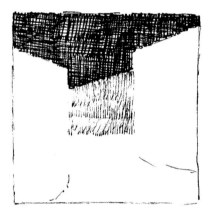

When I introduced the walls and road, I decided to add a medium value to accentuate the illusion of depth.

"Liguria", acrylics on illustration board, 15 x 15" (38 x 38cm)

This painting is part of a series of small landscapes I did from memory of places that are very familiar. My plan was to treat them almost like still lifes, with emphasis on volumes and masses.

I chose to work with acrylics on illustration board, using black, white, Cobalt Blue, Light Yellow and Burnt Umber.

While playing with my shapes for good linear perspective, I decided to increase the realistic side of the painting, breaking the mass of the trees to show some light blue of the sky. This increased the feeling of depth and introduced some calligraphy as well as the few details of the painting. Last I added a triangular dark shape following the movement of the trees.

This painting shows a simple but strong composition, with a well balanced distribution of volumes and an effective use of details.

sketch, trying to preserve the basic value division of the space.

When I roughly transfer my composition to paper or canvas, I choose a very limited palette, often only three colors plus black and white. From then on I work not only on the subject that I want to represent, but more importantly, on the relationship between spaces, shapes, values, colors, textures and lines, never disregarding the initial value division of the space.

This creative process has been very helpful, especially in teaching me to remain faithful to the original structural idea during the evolution of the painting. After many years of painting, I don't always find the need for preliminary sketches, and usually go directly to the canvas. However, I always enjoy experimenting with abstract value compositions, searching for new structural ideas and arrangements. And always, through economy, moderation and simplicity, I try to attain a finished painting showing harmonious balance between space and objects, by a convincing blending of reality and abstraction and elegant sophistication.

"Peonies", acrylics and tempera, 11 x 11" (28 x 28cm)

A gift of peonies from a friend's garden was the inspiration for this painting. Being busy with my family, I wasn't able to paint them until after several days, when only three peonies were left, their stems cut short and their leaves peeled way, but still soft, alive, beautiful.

The chosen colors were black, white, Ultramarine Blue, Alizarin Crimson and Light Yellow. I was particularly interested in playing with different whites, and again I kept simplifying the shapes and reducing the details strictly to the flowers. At the end I added a slightly darker triangular shape on the lower right side of the painting to improve its balance and convey some sense of weight and depth.

I opted for a small square format and a simple value division of the space into three shapes, the white space much larger than the black ones.

Then I set the vase and flowers into the composition, with some modest alterations of the basic shapes.

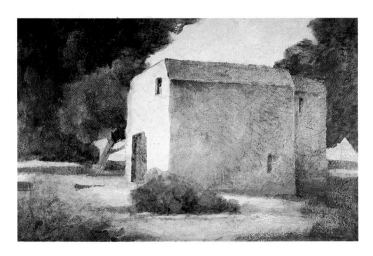

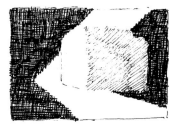

After several attempts, I chose a value division with diagonal directions to achieve some feeling of depth.

To set the house into the composition, I decided to superimpose its volume onto both the light shape in the center and the dark one on the right. I also felt the need to introduce a middle value.

"Farmhouse", acrylics on masonite, 24 x 36" (61 x 91cm)

When I was young, I spent many summers in the hilly countryside between Pisa and Lucca, in Tuscany. I vividly remember the silence, heat and aromas of those places, and, most of all, the dusty stone walls and simple shapes of the century old farmhouses.

In this painting I wanted to recreate those memories, without specific reference to any place or any time. And I wanted to create a large painting.

My chosen colors were black, white, Parchment, Phthalo Blue, Burnt Umber, Light Yellow and Medium Yellow. I chose to use acrylics on masonite, and prepared the surface with slightly textured gesso.

During the process of painting, I felt pleasure in allowing some more realism to take place. I made some small changes and I added a few details. However, my emphasis remained on volumes, both of house and trees, and on preserving the white shape of the initial division of the space.

I am satisfied with this painting. I think it is successful because of its strong structure, the assured and simple composition of its aesthetic elements, and because the tonal ambience conveys a feeling of summer light and stillness on the hills of Tuscany.

"Still Life with White Carnations", acrylics on illustration board, 20 x 30" (51 x 76cm)

This was a semi-abstract composition, involving both still life and landscape.

I decided to use acrylics on illustration board and a very muted palette made with black, white, Cadmium Yellow, Burnt Umber and Raw Umber. I also textured the surface, printing a plastic sheet on a coat of gesso.

During the creative process, I very soon felt the need for another dark shape on the right side of the painting, hence the second vase. In terms of reality, an odd spatial situation took place. However, in terms of abstraction, the new shape brought to the painting good balance and an intriguing combination of flatness and depth. The background landscape requested a lot of texture techniques, while the flowers wanted more realistic details and calligraphy in their design.

In the final picture I can see both reality and abstraction in a well balanced and vigorous composition. At the same time the image expresses simple solidity and austere calmness, while conveying some feeling of mystery in space and time.

The first sketch was of a large light space broken by two different size smaller shapes.

In the second sketch, the vase with flowers was placed so close to the viewer that it could not fit completely in the picture plane.

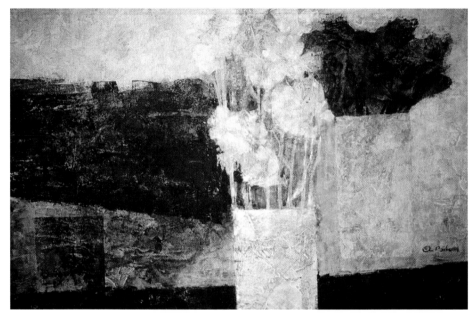

"River Bank", acrylics, 32 x 20" (81 x 51cm)

Like most of my paintings, this one comes from memory. It represents a place and time that alternates between reality and imagination and does not need exact definition. It comes from many walks and bike rides along the lower Fraser River in late fall.

For this painting I joined two canvases together and prepared the surface with textured gesso. I used black, white, French Ultramarine Blue, Cadmium Yellow, Alizarin Crimson and Burnt Umber.

I worked toward the appearance of depth, without completely losing the flatness of the surface. As well, I wanted to achieve a good representation of the fall colors, the blades of water and the foggy sky. All this with a minimal amount of details, that I mainly suggested with textures.

I think that the combination of various aesthetic elements created some subtle and intriguing spatial ambiguity, while achieving the desired delicate balance between reality and abstraction.

My first sketch was the division of a vertical space in several horizontal stripes of many different sizes.

The second step was to create vertical lines, cutting the horizontal shapes, and occasionally form an irregular grid.

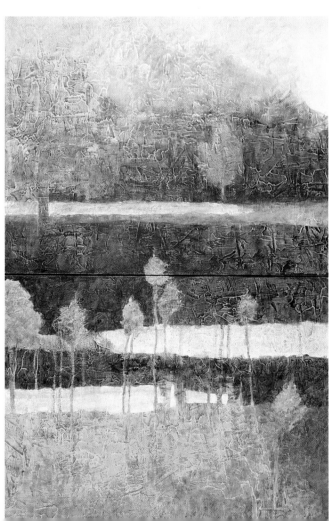

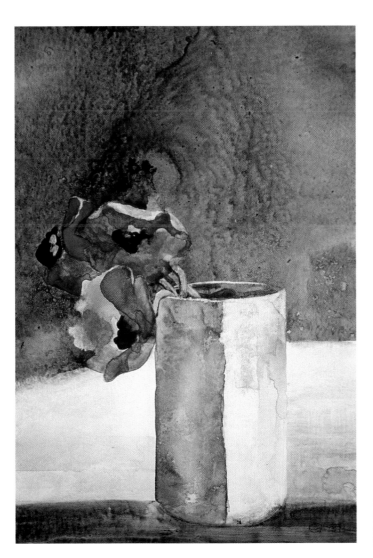

"Anemones", watercolors on illustration board, 20 x 15" (51 x 38cm)

Anemones, are among my favorite flowers, bright in color yet simple, without pretence. I painted these three weary ones leaning in a cylindrical white china vase that I never tire of using in my paintings.

I chose French Ultramarine Blue, Prussian Blue, Yellow Ochre, Lake Red and Ivory Black.

My first concern was to obtain a good spontaneous texture on the background, to give interest to a large empty space. Then I focused on the flowers. I wanted them alive, but not standing out and breaking the background dark. To finish the vase I just played white on white, brushing in and lifting out the paint.

I was happy with this painting. Again, with a remarkable economy of means and very few objects and details, I obtained strong structure, sophisticated texture, tonal ambience and a subtle mood.

My first value sketch looked very simple, however, the proportion relationship of the three shapes was very carefully studied.

In the second sketch I introduced the vase and with it a new middle value vertical shape. I took care to fit the flowers in the dark background.

about the artist

Alessandra Bitelli was born and educated in Italy and emigrated to Canada in 1977. She moved to West Vancouver in 1979.

The daughter of a well-known impressionist painter, Alessandra worked for many years as a miniaturist and illustrator. She now devotes herself to painting and experimenting with water-based media, and giving workshops and courses in watercolor and acrylic techniques.

Alessandra joined the Federation of Canadian Artists in 1981, was elected an Associate Member (AFCA) in 1985, and a Senior Member (SFCA) in 1990. She served as President of the Federation from 1997 to 1999.

In 1989, Alessandra was elected Signature Member (CSPWC) of the Canadian Society of Painters in Watercolor. One of her paintings is now part of the CSPWC Diploma Collection.

Since 1983, Alessandra has had 12 solo shows. She has also participated in numerous international exhibitions, including the American Watercolor Society, National Watercolor Society and Royal Institute of Painters in Watercolors.

Her awards include: AWS High Winds Medal, New York; CSPWC Trillium Workshops Award, Montreal; FCA Gold and Bronze Medals, Vancouver.

Alessandra's paintings grace corporate and private collections in North America, Europe and Asia.

alan**bruce**

the designs in my mind's eye

Could our sense of design spring from the "child within"? And is it about playing with symbols?

Thinking about this essay became an introspection on how my mind operates:
— from the unknown to the known
— from the visible to the invisible
— from the impossible to the possible
— from the horizontal to the vertical
— from the inside to the outside.

Whoever first said "take up art for the relaxation" had no idea what they were saying because it is a life-long experience of understanding, building and expressing your vision; mirroring who you are in time and space, or past time and space in the case of an original photographic impulse; to the process of making it fit your feeling world and the world of your mind's eye.

Teaching is an integral part of being an artist and part of "the process to myself". It is often interesting to ask students to attempt to complete a finished painting in class when you know full well that they can only

Design plans

There are three stages of growth:

✔ The first is the photographic stage.

✔ The second, "lost" stage, is where we ask, what I am doing this for?, as we thump the floor with hands and feet. In the second stage we are coming to grips with our medium and what it can do and what we can do.

✔ The third stage, our individualization in art, is represented by the choreography of the symbols we use and have collected.

a. The original impulse (photographic)

absorb, and they can only create after they have distilled what has been given them. Nonetheless, it is wonderful to watch them all trying at various levels to express themselves.

I normally try to impress on students that it is necessary to gather subject matter that inspires them. It still surprises me when the group copies the same image, to see how different all the attempts are. The exercise not only reinforces how different they all are but how they all chase the same rainbow — the one that turns them into magicians, and illusionists with the brush.

So much of society and schooling has produced minds bearing the stamp of the mechanization concept, which leaves little room for the meshing of true creative viewing with the feeling world.

THE CHILD WITHIN

We have all been given "gifts"; some of us know how to use them, some have to learn how to use them. To the teacher it is normally "a calling". To the student it is a search involving trying varying mediums, music, dance, visual, and various teachers until they can find what "clicks" with them. (I have noticed an increase in the 40-50 year old range, with many of them trying to recapture the "child within" which an artist must possess, and which society often attempts to wean out of them.)

I also suggest students not hanker for success because it is "the process" and the resulting individualization

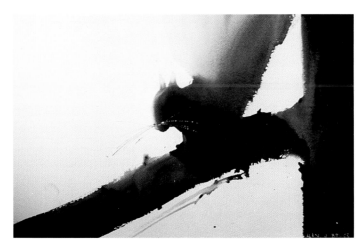

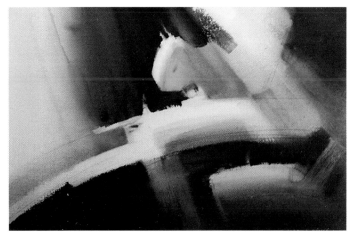

b. The value sketch, or photographic rendition

c. "Squirrel Pattern #1", the intuitive painting, stretching mind and imagination

"Homecoming", 20 x 28" (51 x 71cm)

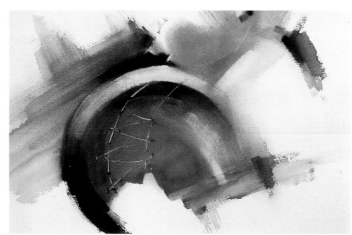

"Can't You Hear The Trees Sing?"

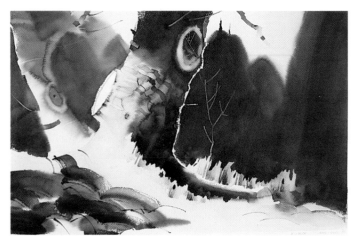

"Good Morning"

"This third stage is what
It feels right/it doesn't fee
counts until

that is most important. If the art you produce is the best you can do, success will come to you in due course, otherwise you can create a whopping blockage — which is what often occurs. The way to establish your art is through honesty and integrity. An abused gift will always fly back to haunt you.

WHAT IS ART?

To get the wheels rolling, I usually ask my students to write out a definition of what art is. I know full well that at the end of the course, when I ask them to re-write the definition, it will in no way resemble the first one. This is only an exercise to help them understand that art is a never-ending process requiring multiple levels of awareness. It requires the student to look inside him/herself to the best of their ability, and exercise their gift to its highest potential. The process of teaching requires the utmost care in order not to harm the vulnerability of the "child within" that the student is endeavoring to come to grips with.

In my own case, I was catapulted into art when I was introduced to the beauty of oriental art and had the opportunity to study with North America's leading oriental artist. This ingrained in me how to make the

"Koksilah Barn"

"The Barn", 20 x 28" (51 x 71cm)
I feel all my barns turn into cathedrals because they are becoming
extinct so rapidly.

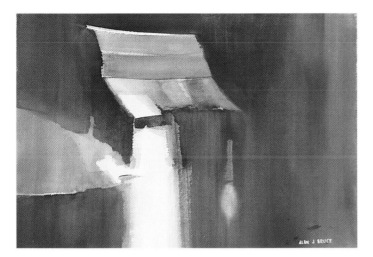

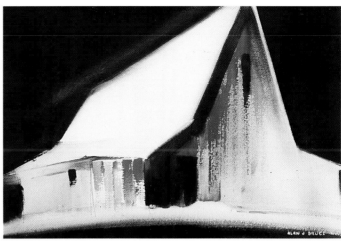

I refer to as "patterning" or painting from within.
right, every element, line, design, color, brushstroke
there is no discordant clash."

brush sing to produce its signature markings. It also
offered me the opportunity to try to understand the
oriental viewpoint — so I was introduced to simplicity
at an early point.

In answer to the question "what is art? the best
definition I can give was prompted a long time ago
when I first saw a reproduction of "The Universe",
a painting by Japanese Zen Master, Sengai. At that
point in my life I did not totally understand what I was
viewing, however, as I matured, the symbols Segai used
became part, parcel and pearls of creation. How could
one explain so much with so little? How could three
simple symbols reach out and grab hold of me? They
held rhythm, excitement, spontaneity and were certainly
part of my "inner child" — they were pieces of art itself.

"The process to myself" is the same for all the arts
because they all represent the same expression, only
the medium changes!

THE THREE STAGES IN ARTISTIC GROWTH
There are three stages of growth.

The first is the photographic stage.

The second, "lost" stage, is where we ask, what
am I doing this for? as we thump the floor with hands

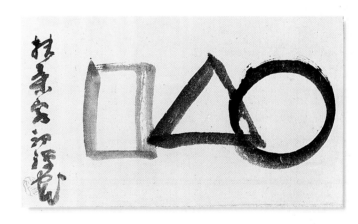

**"The Universe" — Sengai The Zen Master,
Faber & Faber, London, England**
When I first saw this work, its importance escaped me. Later
I wondered how with these three symbols the artist had managed
to explain so much. They held rhythm, excitement, spontaneity,
and were certainly part of my "inner child".

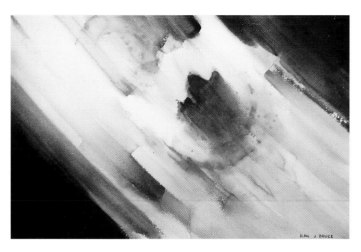

"Sunflower Pattern #2"

"The Violinist", 20 x 28" (51 x 71cm)

"The pure white paper, being the strongest color or manifest form by using a "real" object

"Herald Street Whites", 20 x 28" (51 x 71cm)

and feet. In the second stage, we are coming to grips with our medium and what it can do and what we can do.

The third stage, our individualization in art, is represented by the choreography of the symbols we use and have collected. This third stage is what I refer to as "patterning" or painting from within. It feels right/it doesn't feel right, every element, line, design, color, brushstroke counts until there is no discordant clash. You are creating a symphony on a piece of paper, you are choreographing the dance on a piece of paper, you are creating! (Better make sure I don't have too many sharps/flats or jumps and spins in it.) The viewer is constantly shedding "snakeskins", as they see something not seen before.

MAKING ALL THE PIECES FIT

For many artists, white has become the major "patterning" factor. How do you arrange this? The pure white paper, being the strongest color in the palette, has to be balanced with the abstract or manifest form by using a "real" object lest the viewer becomes lost in the abstraction.

At this point, the artist has the job of delineating, arranging, rearranging, trying this position versus that position, until all the pieces fit. You have the obligation to produce only the best, and must force or catalyst

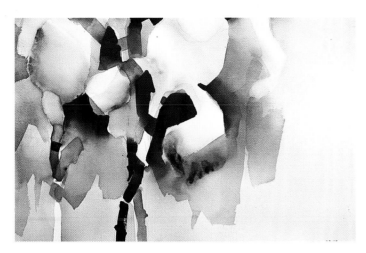

"Early Morning Iris", 20 x 28" (51 x 71cm)

"Ode To Joy"

in the palette, has to be balanced with the abstract lest the viewer becomes lost in the abstraction."

yourself into that position. You are constantly challenging yourself. It is also the artist's job to educate, with the moral issues being high, because so many times mediocrity is sold and accepted because of ignorance. As we educate to enhance an understanding of the creative process, slowly the wheels churn and a few more come to realization of the disciple/discipline relationship required to make a piece of art look so simple, smooth and easy. Art cannot help but invoke the philosopher's stone, religion, viewpoints, for it encompasses them all and the mathematics therein.

Our society does not offer the protection so often necessary to the talented or serious artist. To me the struggle is all part of "love's labor" or "the process" of teaching something that can't be taught or writing something that can't be written. However, that's our mission, just to get people to see, and see a little further still. It's about stretching sight and imagination and formulating it into beauty to make the world just a little better.

A thank you to the publisher for extending the opportunity and having the intestinal fortitude to invite some of us to bring forth our viewpoints for we all have facets of the diamond and in putting them together we may create "the jewel".

I and my 1970 VW van — a symbol unto itself — wish you all the best.

about the artist

Alan J Bruce is an elected signature member and regional representative for the National Watercolor Society (NWS), Los Angeles, California, USA.

His work has been published in several compendiums of Canadian artists, and his work has been hung in many prestigious exhibitions, including the 70th Annual National Watercolour Society Show, the Federation of Canadian Artists show, the Musso de la Acuarela Mexicana, Mexico.

Alan was a featured artist in *International Artist* magazine. He currently lives in Victoria, BC Canada.

donfarrell

how I search for rhythm and harmony

Once we are aware of the foundations of composition, the fascinating subtleties come to the forefront: Determining how the viewer's eye will move through the composition; Providing pauses and punctuations; developing rhythm through repetition and parallels; providing a feeling with placement and the relationships between the positive and the negative.

My approach to painting begins and ends with composition. I find this pursuit fascinating and challenging and, most importantly, never conclusive.

Painting is of course multifarious, and for all of us the goal is, gaining control without impeding the creative process.

I must say at the outset, that striving for the seed, or feeling, which sparked the idea for your painting is always paramount. Nurturing your intuitive responses, allowing the paint to take you toward the unanticipated, is most important. The goal is to be aware of the rhythms and harmonies of composition without over-formulating.

Design plans

✔ Think in terms of shape.

✔ Provide divisions and structure with parallels.

✔ Think about blending rectangular motifs with triangular and oval sub motifs.

✔ Make use of rhythmic relationships.

✔ Connect and divide.

✔ Use shape relationships to control eye movement.

✔ Introduce pattern.

THINK IN TERMS OF SHAPE FIRST

Thinking of your paintings as an arrangement of shapes is a good way to begin.

A composition should have motifs, which are the prominent shapes that make up the painting. For example, a painting could have the rectangle or the triangle as the primary motif. The primary motif would be supported by sub motifs, which are secondary shapes for creating interest and balance. In other words, a composition would have a rectangle motif with triangle and oval sub motifs. When we seek shapes we are beginning to gain control.

I work primarily with still life but I should emphasize that subject is not the key. Seeking rhythm and harmony through shape, value and color relationships is the objective.

THEN APPLY THE FASCINATING SUBTLETIES

Once we are aware of the foundations of composition the fascinating subtleties come to the forefront: Determining how the viewer's eye will move through the composition; providing pauses and punctuations; developing rhythm through repetition and parallels; providing a feeling with placement and the relationships between the positive and the negative.

Trying to grasp the intangible, sensing the interplay between the emotional and the rational, is intriguing, ongoing, evolving.

I am convinced we all have a personal sense of composition. The challenge is finding ways to let it come forth.

Study the masters, especially the modern masters, and note what appeals to you, not subject matter, but rather shapes, proportions and color. Taking note of what appeals and does not appeal to you will bring your tendencies to the forefront. Growth comes from heeding and trusting your senses.

I have provided a number of samples of my work along with the thought process that went into each composition. I hope they will provide you with some insight on how a painting evolves.

Dividing the composition with the white strip of cloth was the seed of this painting. That white slash holds the eye. I took great care to avoid distractions or unnecessary competition. Providing oblique movement with parallels is the key.

Note how the pot's shadow is supported by the parallel shadows at the right and the left. The parallels of the creases in the cloth provide subtle counter movement.

A subtle and very important harmony is created by the shape and size relationships of the oval shadow in the pot and the shadows of the knobs. The two smaller shapes echo and support the larger shape.

The angle of the shadow at the bottom left is independent, but I felt it was necessary to provide a feeling of stability.

The large dark portion of the composition is very important. It contains subtle harmonies, which support and connect to the area of interest.

Note the light circular shape near the top, how it echoes the knobs and how the pot is placed between this and the right knob. This provides a sense of division.

Another important subtlety is the line that connects the seam in the pot to a vertical scratch on the drawer below, this creates a sense of structure.

DIVISIONS AND PARALLELS

"Creases", mixed media, 10½ x 12½" (26 x 66cm)

As with most of my compositions, the rectangle is prominent, being supported by the triangle. The painting is divided horizontally into three areas by slightly oblique parallels and by using color and value differences.

Note how the tabletop echoes the two large shapes behind and above the table, and how the drawer subtly relates as well. These provide harmony.

The angled shadow on the front of the table at the left is parallel with the shadow on the wall at the right. The shadow of the table at the left is paralleled by a line on the wall. Notice how this relationship divides the composition and brings you to the area of interest.

Every shape and mark is assessed for a relationship, the knob on the drawer is a good example, its shape and size relates to the top of the bottle and the sight line they create is paralleled by the table's shadow and the line on the wall.

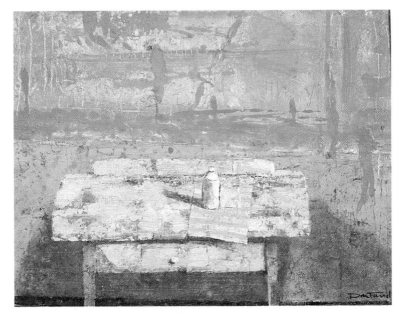

Note the vertical parallel lines at the left and the right of the composition and how these hold your eye movement, providing containment.

I provided a large suggested shape of a triangle on the wall, to attract the eye. Note how it connects with and embraces the focal area of the bottle, bag and striped cloth.

The bottle's shadow provides a parallel for the front edge of the cloth, which is supported by a subtle parallel on the wall. Last but not least are the parallel stripes on the cloth.

PROVIDING DIVISIONS AND STRUCTURE WITH PARALLELS IS THE BASIS OF THIS COMPOSITION

"Blue Stripes", mixed media, 9½ x 12" (24 x 31cm)

The relation between the pot and the orange interior was the seed of this composition. The windowpanes provide a repeating rhythm of vertical rectangles, which establishes the primary motif.

The orange interior has a rectangle feel along with the dark area in the window, just below the blind, which emphasizes the primary motif. Note the large triangle shape across the bottom. This provides a sight line, which intersects the pot.

To ensure the composition was not static, which occurs when verticals and horizontals are prominent, I provided two slightly oblique parallel shadows, one on either side of the window. These also hold the eye and support the inward leaning of the white recess at the left of the window.

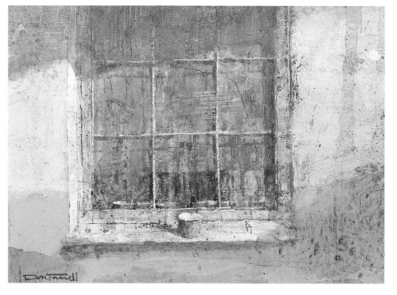

The large triangle shaped shadow at the top parallels the bottom triangle. This creates a diagonal movement across the painting.

The oval shape of the pot's top is the focal point. This was mirrored by a white oval shape near the top right. You can feel the visual pull between them. Without that relationship the composition would have a very different feel; the pot would be too isolated, holding your eye. Notice how the orange of the interior wall is between the two ovals. This, along with the color balance between the green blind and the orange interior, creates a harmonious relationship.

Note the white ambiguous shapes running along the bottom of the windowpanes and how they add interest without competing with the pot. This pursuit of balance and relationships is never conclusive but always fascinating.

THIS PAINTING HAS A RECTANGLE MOTIF WITH TRIANGLE AND OVAL SUB MOTIFS

"Orange Wall", mixed media, 9 x 13" (23 x 33cm)

I love the shapes of these chairs, and they initiated the composition.

I began by placing the chairs and then made sure their shapes varied enough to provide a harmonious relationship.

The placement of the bag strengthens the angle of the right chair. The angle of the corner of the wall is in harmony with the curves of the chairs. I also provided a curved shadow at the right of the chairs to support and embrace the chairs.

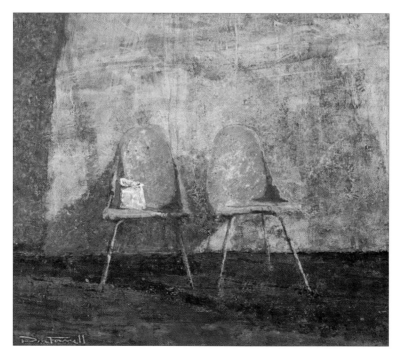

A very important rhythm is created by the slightly curved shadow of the chairs and its relationship with the curved shadows in the chairs. Notice how they relate to the bag. The bag is the focus, and is supported by the echoing shapes created by the legs of the chairs.

The angled shadow on the floor leads to the left chair and runs parallel with the top of the bag. Also note how the angle of the right edge of the bag relates to the shadow behind the bag and a shadow line on the wall, just to the left the chairs.

I avoided introducing other elements in the large negative areas — you must be careful, there is a fine line between distraction and relationships.

SHAPE WAS THE INSPIRATION

"Moulded Chairs", mixed media, 8½ x 10" (20 x 25cm)

This composition is about vertical and horizontal divisions. I use value, the dark shapes at each side, for impact. Making them lean inward gives a sense of mass and weight to the wall.

The horizontal divisions are very important, their arrangement is the key to the composition. I began with the strong line running across the wall and then established the supporting parallels.

A very important connection is the loop shape with the vertical lines just above the strong light line above the cans. Note how the shape relates or connects to the table, and how the shadow at the top left parallels the right edge of the table.

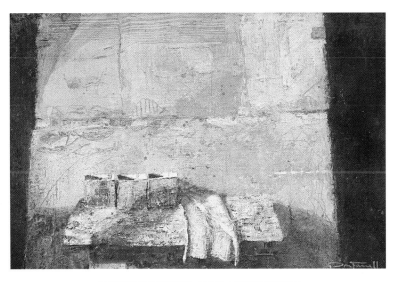

Note the two reddish shapes near the top and how the eye connects them with a sight line, and how this is reinforced with subtle horizontal markings. The other important horizontal is created by the top openings in the cans and the relationship with the chalk line to the right, another sight line.

There are markings and shapes on the wall that support the cast shadow on the table. I strive to provide a relationship for every mark.

The horizontal of the table provides the related base. The repeating triangle shapes, the shadows in the cans, establish rhythm. Note how they harmonize with the shadows of the can and of the table on the wall.

CONNECTIONS AND DIVISIONS

"Chalk Line", mixed media, 8 x 12" (20 x 31cm)

This composition is an excellent demonstration of motifs (shapes) and their relationships. The seed of the composition is the circle, which I modified to suit. The circle is sensed. The curve of the shelf connects to an arched line on the wall. The arch is shifted to the left to establish the desired relationship with the rag (a triangle) on the wall.

The background is an arrangement of rectangles, which is supported by two triangles, one at the bottom left the other at the top right. Note how the parallel edges of these triangles provide an oblique movement. The objects on the shelf are an arrangement of rectangles and triangles.

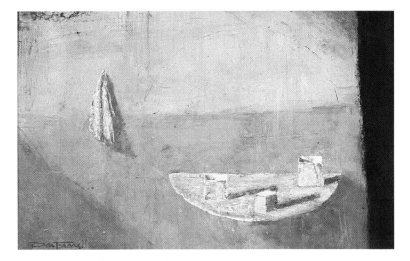

Another oblique rhythm is provided by the parallel shadows on the shelf. I provided some dark markings at the top right to hold the eye movement within the composition. The darks echo the curve of the shelf and then lead the eye to the rag on the wall. Note as well their value, which is close to the values of the shelf and rag, if they were darker they would spoil the relationship between the shelf and the rag. I should point out how the shadow of the rag strengthens the connection with the shelf.

There is also a subtle vertical division of the composition just to the right of the rag, which supports the verticals of the rag and the boxes on the shelf.

SHAPE RELATIONSHIPS AND EYE MOVEMENT

"Semicircle", mixed media, 8 x 12" (20 x 31cm)

"I emphasize that subject is not the key. Seeking rhythm and harmony through shape, value and color relationships is the objective."

This composition has a rectangle motif, supported by the sub motifs of the triangle and the circle. First, I divided the background vertically creating the rectangle motif. The vertical dark shadow leads the eye directly to the jacket. The jacket's shadow leads to the handle.

Parallels, such as the handle and the back of the jacket provide rhythm. Another example is how the edge of the shadow on the wall at the upper left, leading to the collar, echoes the direction of smaller shadows running across the jacket and wall. The shadows running across the jacket lead to and connect with the handle.

The horizontal shadow on the wall at the top of the handle connects to the shadow at the right, dividing the composition. There are no limits, the fun of it is finding or creating relationships for everything. Nothing should be isolated.

Note the punctuation of the small dark dot to the left of the handle. It provides a visual pull and also relates to another dot at the right edge. The sight line between them harmonizes with the parallels of the diagonal shadows on the wall.

RHYTHM AND CONNECTIONS

"Jacket and Handle", mixed media, 7½ x 10" (19 x 25cm)

The curve is the basis of this composition. The tabletop provides the base of the composition. Its curved shape echoes the curve of the shadow at the top, creating a horizontal upward swing to the right. The placement of the drawers was carefully considered to harmonize with the sweep.

Note how the right drawer connects or relates to the two ambiguous shadows above. This provides a counter movement to the swing to the right.

The cast shadow at the bottom left provides entry to the composition and is in harmony with the sweep.

The subtle vertical lines at the right hold your eye movement, providing containment.

Notice as well the subtle parallels in the background and how the angle of the right drawer is in harmony with the cast shadow. I felt the top of the table needed a relationship, which resulted in an intuitive placement of a horizontal line across the composition.

I would like to point out the very important rhythmic relationship between the two knobs and the two ambiguous shadow shapes at the top left. This is the key to this composition.

RHYTHMIC RELATIONSHIPS

"Three Drawers", Mixed Media, 13 x 17½" (33 x 44cm)

"Trying to grasp the intangible, sensing the interplay between the emotional and the rational appeal, is intriguing, ongoing, evolving."

The pattern is limited to the panel and the more subtle repeating horizontal shapes in the chairs. The key is to provide shape relationships that are harmonious.

The shelf with the red box, is the counter balance to the focal area of the panel and the chairs. They relate to the panel with color and value and their shapes relate to the chairs.

The rectangle is the primary motif, the panel with its check design, the shapes of the chairs, the wall and that very important light switch which provides a visual pull.

The punctuation of the composition is the prominent red square within the check pattern. I arrived at its placement after most of the composition was completed.

THIS COMPOSITION IS A STUDY OF THE USE OF PATTERN

"Squares", mixed media, 7 x 10" (18 x 25cm)

The leaning shadow between the switch and the chair relates or parallels a light patch to the left of the folded chair, introducing another oblique which supports the relationship between the panel and the shelf.

I introduced oblique parallels on the floor area to relieve the horizontals and verticals of the rectangle motif and to provide entrance to the composition. The shadows of the chairs and shelf and the angle of the large shadow just above the shelf provide another oblique rhythm, supporting the visual pull of the light switch.

There is a very subtle line leading up from the light patch at the left, then across the top and then leading down to the right of the unfolded chair. This prevents the eye from meandering.

When we bring relationships to the forefront of our thought process we find ourselves on that marvellous path of developing our own style. We all have our own sense of balance and rhythm, it's a matter of trusting it.

about the artist

Don Farrell was born in 1942, in Vancouver, British Columbia, Canada, and now resides on Vancouver Island.

Don has entered many juried shows and has received numerous awards. In 1984, he won the RI Medal, as well as Honourable Mention for work submitted to the Royal Institute of Painters in Water Colours annual exhibition in London, England. In April of the same year Don was elected a full member of the Royal Institute.

Don also entered works in the annual exhibition of The Royal Society of British Artists in London, and was elected an associate member of the Society in 1984. In July 1985, Don was notified that he had been elected a full member of the Society.

In 1989 he was elected a signature member of the Federation of Canadian Artists after having been an associate member of the Federation since 1983.

He has won several important awards. In September 1992, Don received an award in a joint exhibition of signature members of the Federation of Canadian Artists and Australian Watercolour Institute which was held in Vancouver, Canada.

In 1998, Don exhibited with the Sui Generis Gallery in the Vancouver International Arts Fair. In 2000 he participated in the 20/21 British Art Fair in London with the Adam Gallery.

His work hangs in HRH the Prince of Wales collection, as well as many private collections in England, Canada, the United States, Australia and Europe.

He is listed in "Who's Who in Art in Britain". Don regularly takes part in the annual exhibitions of the RI and RBA at the Mall Gallery in London, and he is represented by galleries in Britain and Canada.

Don teaches privately and lectures on composition and creative development.

I take risks to find clever and exciting solutions

Composition is another word for arrangement. Ideas and visual information have to be sorted and arranged within the format of a painting while ensuring that tone, color, and line play their separate parts to produce a cohesive and balanced whole. As I see it our job as designers is to find as many varied routes for the eye to follow through the composition as possible . . . and we must be prepared to take a few risks.

Composition. Do not be frightened by such an imposing title. After all, you can probably remember writing your English compositions (essays) at school. This was really a matter of arranging your thoughts in some order, and putting related thoughts into a paragraph. It was, of course, necessary to use punctuation and grammar to make your writing read sensibly. It is very much the same when it comes to composing a painting. Composition is really another word for arrangement. Ideas and visual information have to be sorted and arranged within the format of a painting while ensuring that tone, color, and line play their separate parts to produce a cohesive and balanced whole.

Most paintings exist on two levels, subject matter and abstract structure. For example, if we want to paint a landscape and have chosen a suitable location, we have to decide what is worth looking at and should be included in a painting and that which we must reject as being unworthy.

Design plans

✔ Find balance.

✔ Use geometry.

✔ Design with triangles.

✔ Design with circles.

✔ Combine opposites.

✔ Take risks.

On the abstract level we have to control the structuring of shapes, tones and colors within the rectangular two-dimensional format of the painting. The easiest way to paint is to just copy nature or, better still, copy a photograph of a view. The camera presents the view as a flat rectangular print which makes copying easy. The problem is that the camera does not compose for you and does not work like the human eye. The human eye chooses what to look at, while the camera sees everything in front of it with equal intensity and mostly with all parts in equal focus. The trouble is that, at the end of the day, you produce an insignificant work and if it is a copy of a photograph all you have achieved is a photograph made by hand. This may have been worthwhile as therapy and you may feel better for having done it but it is doubtful if you have produced anything creative. At least photography gets linear perspective right and gives some added sense of space through recording some aerial perspective.

American artist Charles Sheeller made a very shrewd assessment of the worth of relying on a photograph when he said,

> *"Photography is nature seen from the eyes outwards. Painting is nature seen from the eyes inwards."*

When I was in Bruges 10 years ago I made drawings of some of the remarkable buildings for which the city is famous, with the intention of making paintings from the studies when I returned home. It so happened that I had my camera with me and after completing one drawing I took a photograph of the scene. Both the photograph and the final painting "Roofscape, Bruges" are reproduced here and I hope it is clearly evident that I avoided using the photograph in favor of working from my drawing which contained the embryo of the ideas I wanted to include in the final work.

THE DIFFERENCES BETWEEN NATURE AND PAINTING

Nature is vast and has no boundaries. Start by looking at the weeds under your feet, raise your eyes to look to the horizon and higher still to the sky. By turning your feet through 180 degrees you can look at the sky that was behind you, then the far horizon and finally the ground that was originally at the back of your heels. A world

Photograph of the scene

"Roofscape, Bruges", watercolor, 30 x 22" (76 x 56cm)

without boundaries. Similarly, by looking first to your left and then following the horizon towards your right and then pivoting on your heels to follow the horizon round behind you, eventually you return full circle to where you began.

In other words you are standing in the center of an immense sphere of the space that surrounds you. Light and darkness, the seasons and weather conditions create radical changes to our perception of what nature looks like. How different is a painting which exists as a small, static flat rectangle where wind, rain and light conditions are frozen for all time. This is the painter's world within whose strict limits we have to create our intellectual and emotional response to our subject matter.

Our world, unlike the real world, is confined by two verticals and two horizontals making four right angles where they meet. If you stop to think about it you will realize what an absurd restriction this makes. So here we are, with a situation that makes it quite impossible to copy nature, unless of course we are prepared to "cut out" a little piece of it and copy that.

Our world, is one of geometry combined with the human desire to create, by distortion, an emotional work in which all the elements that are important to us are exaggerated. Whatever we do, geometry is always there forcing us to relate our lines, tones, shapes and colors to the rectangle of our canvas or paper.

John Marin, the American watercolorist, wrote in 1931:

"To get to my picture . . . I must for myself insist that when finished, that is when all the parts are in place and are working, that now it has become an object and will therefore have its boundaries as definite as the prow, the stern, the sides, and bottom bound as a boat."

How often have you heard it said that nature is perfect and therefore it is unnecessary to do other than copy her? James McNeil Whistler, in his 1888 "Ten O'Clock Lectures", gave an excellent rebuff to this point of view.

"Nature contains the elements, in color and form, of all pictures, as the keyboard contains the notes of all music. But the artist is born to pick and choose, and group with science, these elements, that the result may be beautiful — as the musician gathers his notes, and forms chords, until he brings forth from chaos glorious harmony. To say to the painter, that Nature is to be taken as she is, is to say to the player, that he may sit on the piano. That Nature is always right, is an assertion, artistically, as untrue, as it is one whose truth is universally taken for granted. Nature is very rarely right to such an extent even that it might almost be said that nature is usually wrong — that is to say , the condition of things that shall bring about the perfection of harmony worthy of a picture is rare . . . seldom does nature succeed in producing a picture."

RULES OF COMPOSITION

To help us put a convincing picture together during our early days of learning to paint we probably accepted some simple rules. For example:

1. Never divide your painting into two equal parts.
2. Avoid placing your main point of interest in the center of the picture.
3. Avoid placing areas of interest in the corners of your composition.

HOW RULES CAN BE BENT

As we grow in confidence we begin to accept that these, and many others beside, are not hard and fast rules but are simply points of guidance which can be followed or ignored as we wish. But be wary, rules laid down to assist the new painter should be set aside only when there are excellent reasons for doing so.

One of my abiding interests is the painting of military uniforms. I visit many of the Military Museums in the South of England and Paris enjoying looking at and drawing the uniforms on display. All of them are skillfully designed and are beautiful things in their own right, as well as being garments made to make the wearer imposing and godlike, both in times of peace and war. The sad thing is that these wonderful uniforms encourage young men to enlist in an army, only to get themselves killed on the battlefield in some useless war. Nevertheless, my imagination is stimulated when I consider a particular uniform and speculate on what manner of man would have worn it, his background, his loves, and his ambitions. So, I use photographic images pertaining to the period, to weave imagined visions from his short life. The painting "I am Glad My Sort is too Young to Fight" is a First World War officer's dress uniform which I have chosen to demonstrate how "rules" in art can be bent or ignored.

Hardly a rule, but of great importance, is developing the ability to arrange the composition in such a way that

**"I am Glad my Son is Too Young to Fight",
acrylic, 25 x 16" (64 x 41cm)**

First of all the uniform, which is shown full frontal, appears to sit in the middle of the composition with the toggled fastening dividing the painting into two vertical halves. The illusion is one of symmetry, but in fact the two halves are far from equal. The painting is also divided in two by the strong diagonal line made by the black leather bandoleer belt which is continued above and below by the diagonals of the Union Jack. This is an example of another dangerous thing to do but I have got away with it because the line above, marked by the red of the flag, is continued by the white instead of the red strip in the flag below. Actually the color and tone changes serve to disguise the strength of this division coupled by the way our eye is diverted by the silver lion head medallion with its chain connected to the silver metal device for spiking guns.

Another consideration is that the bandoleer belt helps to bridge and join together both the vertical division down the center of the uniform and the white vertical of the flag to the left of the picture,

which continues right to the bottom of the painting through a gap in the marching soldiers. Now look again at the painting and remember the "rule" about avoiding placing things of interest in the corners and you will notice that family photographs of the period are brazenly displayed in the two top corners, and even an army lorry takes our attention in the bottom right corner.

It would be easy to assume that these compositional inconsistencies had all been carefully considered before work began, but this would not be altogether true. Admittedly, the general placing of the uniform was decided at the onset, but the Union Jack was introduced much later, motivated by the design needs suggested by the diagonal bandoleer. The fact that the vertical white strip of the flag passes through the gap in the First World War photographs on its way to the bottom edge was completely fortuitous. A painting is a living thing and has to grow and change and develop in concept, within one's head and also within the rectangle of the composition.

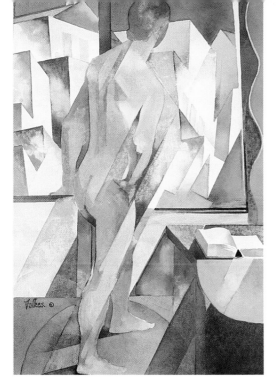

**"Nude In Front of a Window", watercolor,
21 x 13½" (53 x 34cm)**
The angles of the shadows suggested a diagonal grid to produce this Cubist influenced picture. A number of entrance points were conceived on the left side using the obvious horizontals of the window sill, floor, and the abstracted buildings outside the window.

Most important is the strong diagonal from the bottom left corner leading the eye upwards, through the figure, which is also supported by other numerous parallel diagonal lines.

Another line, following the right shoulder up the chimney on the roof top and down to the corner of the window, provides alternative routes for the eye to travel back to the left of the work and up to explore the design routes at the top. The snake-like curve of the curtain makes a barrier to prevent the eye exiting from the right side of the picture, with the book and the drop-leaf table directing the eye back into the painting.

Another way of leading the eye is by using a combination of "lost" and "found" contours. If the tones on either side of a contour line become of similar strength at certain points, a path is provided for the eye to move across from one side of the line to the other. It is like the country walk, where a fence along a road or round a field has been broken down, allowing easy access for the walker.

Examples of this can be seen in the painting where the left buttock meets the left and where the right shoulder meets the background.

there are numerous paths through the work which the eye may follow. The eye is not happy to be confronted by obstacles, and the subsequent effort needed to jump from one part of the picture to another. If we are on a country walk and find our progress impaired by a river it is doubtful we would be prepared to wade across. Normally we will follow the river bank until we come across a bridge or a ford where we could cross in comfort. Invariably the enforced detour contributes to the enjoyment of the walk because many new vistas open up for us to explore.

As I see it, our job, as designers is to find as many varied routes for the eye to follow through the composition as possible. It is necessary to bear in mind that we are conditioned to reading from left to right and because of this, the eye normally looks for a point of entry into the painting from somewhere on the left margin. With skill, visual blocks can be used to prevent the eye escaping at the right side, with additional lines to encourage the eye back towards the center of the picture.

My watercolor "Nude in front of a Window" is an example of a painting that originated from a life drawing of a male model posed in strong side lighting.

BALANCE

Balance is an essential ingredient of composition, without it your painting looks uncomfortable and appears to be falling over. It is important to understand that balance does not necessarily rely on the same tones and colors being mirrored on both sides of the work. Remember the well known scenario of a pound of sugar balancing a pound of feathers on your kitchen scales. There is a colossal difference in volume between the two but the weight is the same.

In a similar way a large uninteresting mass on one

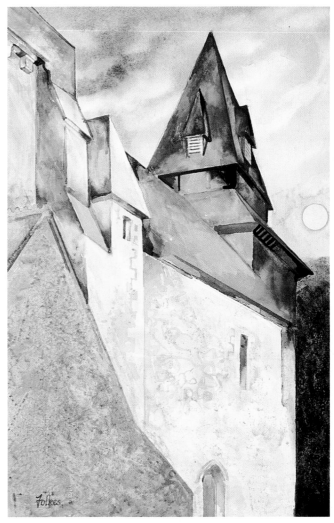

**"Easton Church", Evening, watercolor,
21 x 13½" (53 x 34cm)**
The interest in this painting is concentrated on the wooden tower and spire and the setting sun, all on the upper right side of the work. The simple large masses of the gable and stone wall on the left create a daring balance of mass balancing interest.

side of a painting can be balanced by a small area of interest, like a figure, on the other side.

My painting "Easton Church, Evening" which was painted in the studio from a drawing made on the spot, demonstrates this point.

You will have noticed that I am talking about balance from side to side and not top to bottom. All our experiences in art closely relate to our experiences in nature. It is common knowledge that it is much easier to carry a heavy weight if it can be divided, allowing half to be carried in each hand. If this is not possible, for example when carrying a bucket of water, it is usual to hold a heavy piece of metal in the free hand to help balance the weight of the bucket, despite increasing the total weight of the load. African women can carry heavy weights by walking with them on top of their heads because, through gravity, the weight is centrally positioned over their feet. The weight of the load may cause the woman to collapse, in the same way as a building may collapse where the weight is too heavy to be supported by the foundations, but the collapse, in either case is not caused by a lack of balance.

Some paintings are capable of being viewed any way up especially if they are abstracts, but many, where the top of the painting appears heavier than the bottom, or vice versa, will not appear to balance when the painting is turned on its side. Balance is only a consideration when comparing one side to the other.

However the weight of the top compared with the bottom is an interesting element of composition, if not one of balance. We generally accept that the greatest weight should be at the bottom. Probably because in

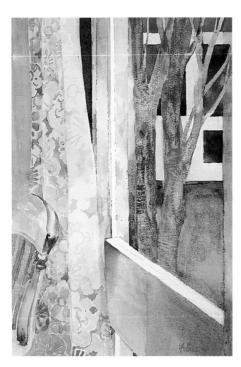

"Window at St. David's", watercolor, 21 x 13½" (53 x 34cm)

I was fascinated by the contrast between the warm colors of the interior and the cold somber ones outside. Accepting the challenge to try and solve this dichotomy I divided the painting into two near equal vertical strips, with strong warm colors of light tones on the left and strong neutral tones on the right. My problem was to unite the halves without losing their individual character. Fortunately, the horizontal transom of the window served as a linear and color link which enabled me to contrast the gentle curtain and chair design with the harsh texturing of the trees outside.

"Downs above Mere", watercolor, 13 x 13½" (34 x 34cm)

Also involved with color, the design of this painting was concerned with the use of large interlocking forms of strong color. The majority of this work was carried out in front of the landscape using strong contrasts of color or tone to chisel out both space and design. Complementary colors of green red and pink were set against the harvested yellow cornfields which in turn were set against the complementary blue violet and blue grays of the background.

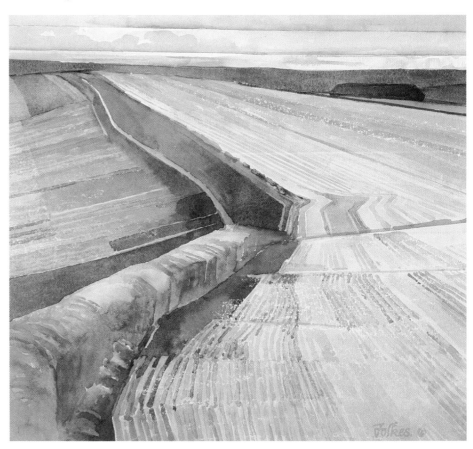

nature sky is normally light and the ground is darker. Sometimes it is interesting to reverse this and make the top heavier than the bottom. This is easy to do with an abstract, but not always easy with a landscape, unless the subject is a cornfield under a stormy sky, a winter scene with snow-covered fields under a gray sky, or even a night scene with spotlit buildings under a black sky.

Balance can of course be achieved through the use of color instead of tone. Just as a small interest can balance a large mass, so can a small patch of bright color balance a large mass of neutral color. Many balancing games can be played with color. For example a large amount of bright color can be balanced by a small area of a complementary, providing the complementary color is not used anywhere else in the composition.

The one thing to avoid is creating a balance in an obvious way by repeating what is happening on one side with the same or something similar on the other. Of course this works perfectly but is usually downright boring. To make exciting pictures we must be prepared to take a few risks in order to find clever and exciting solutions.

USING GEOMETRY

Accepting that a painting normally exists within a rectangle, and is therefore governed by the laws of nature, Picasso expressed this very well in his writings of 1923 when he said:

> "Nature and Art, being two different things, cannot be the same thing. Through Art we express our conception of what nature is not."

Whether we paint naturalistically or abstractly we have to organize our painting in terms of lines, squares, rectangle, triangles, ovals or circles, to create a relationship with the rectangular frame.

We do not have to go to the extreme of Piet Mondrian who, in his late work, used only lines that were vertical or horizontal to reiterate the sides the top and bottom of the picture. He created squares and rectangles from these lines and filled in the shapes with primary and secondary colors, plus black, gray and white. Working with such limited means made demands of accuracy in the creation of emotional content and the intellectual ideas.

Whether or not we go to this extreme we cannot totally ignore the needs of geometry in our quest for a perfect composition. As soon as we place a horizontal line across our painting we are half-way to suggesting a horizon or, alternatively, the meeting of a floor with a wall. However we intend to use this line, the proportion between the two shapes becomes an aesthetic choice. Making them both equal, or deciding which should be bigger is easy to judge, but deciding by what amount one should be bigger than the other is a very difficult decision to take. With practice we develop a subconscious ability to make the right choice, but while

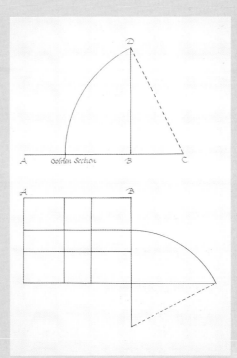

The golden section explained

When we divide a rectangle in two there must be a point at which the relationship between the parts is most pleasing. To help us, mathematics can supply an excellent answer. If we take a line the length of one side of the rectangle and call the line **AB** we create an aesthetic and intellectual division at **C** when the proportion between the two halves can be expressed as a ratio. **AB : AC** is similar to **AC : CB**. That is the length of the whole line, divided by the length of the larger part must be in the same ratio as the length of the larger part relative to the smaller part.

Many photographers use a rough and ready equivalent of the golden section by saying that the proportion of AC to CB is 3/5 to 2/5. However if we are going to use the golden section to train our eye, it is important to get it right. Expressed arithmetically it is 0.617 to 0.383, but for us practically minded artists it is easier to find the division by the use of geometry.

To find the golden section of a line **AB** extend **AB** to **C** making **BC = AB**. From **B** erect a vertical line to **D** so that **BD** is equal to **AB**. With **C** as center and **CD** as radius, draw an arc cutting **AB** at the golden section.

If **AB** is the length of the bottom of your rectangle then you can use the same measurement along the top, and if the construction had been made the reverse way round you will have another golden section closer to **B**.

Repeat the same construction for the short sides of the frame and you will have a rectangle with two golden sections marked on each of the four sides. If marks on opposite sides are joined together you will end up with a grid (see diagram) which will give you a number of points of perfect proportion where you can place important lines and at the intersection of these lines you will find positions for placing elements of importance.

we are learning it is useful to fall back on the well tried method of creating a golden section. The accompanying sidebar explains the golden section in detail.

The Greeks made use of the golden section proportions in the design of their temples and through the ages a number of painters have used them in the organization of their compositions. When I was a student I constructed these sections on every canvas and was pleased to rely on their help. I do not know if my eye is now well enough trained or if I have grown too lazy to construct them!

Nevertheless, my interest in the geometry of picture making has grown steadily over the years as can be seen in my painting **"Fort at the Entrance to the River Dart"** which was made from a quick study since I had to lean uncomfortably, and precariously, over the battlements.

DESIGNING WITH TRIANGLES

The Cubists, of 1907-1914 tried to design their paintings using angles in preference to curves, because they discovered that this produced more dramatic pictures. The edges of shapes were made to be at an angle to the side of the frame to create more forceful and dynamic compositions. I have always been interested in the philosophy of their approach where they felt the artists had the freedom to view their subject from slightly different points of view and have the ability to change the light source in order to explain form in a more lively manner.

A few years ago I made a number of drawings and a painting of a church at Brown Candover in Hampshire. It is normal to be disappointed with the work that has been produced but on this occasion my disgust was such that there was nothing for it but to begin again. The painting **"Preston Candover Church No. 2"** began at once, but I quickly ran out of steam, and doubting what I was doing, the work was left for three years before I picked it up again, determined to finish or bin it! Often I find that when I do not care about a painting I produce my best work.

"Fort at the Entrance to the River Dart", acrylic, 20½ x 14" (52 x 36cm)

I was impressed by this small fort that stood resolutely protecting the entrance to the wide River Dart and the old town of Dartmouth further up the river. Verticals, horizontals and, by implication diagonals, provided a robust structure which developed as a diamond composition as the painting progressed. The spatial depth in the work, combined with abstract elements of design, forged a powerful Cubist image.

"Ramsbury Church Tower", watercolor, 21 x 13½" (53 x 34cm)

Cubism came to my aid in the production of "Ramsbury Church Tower". It was extremely difficult to capture the grandeur and height of this tower on a small piece of watercolor paper. By carefully composing the tower and avoiding traditional perspective I was able to get somewhat closer to my aim. Areas of light and tone were distorted to lead the eye upwards from the base of the hill on which the church stands, with abstract 'slabs' of sky creating a contrived space behind the tower.

"Preston Candover Church No 2", watercolor, 21 x 13½" (53 x 34cm)

This painting demonstrates a well-tried compositional device of using triangles to hold the structure of the work together. Reiteration was used to enforce the dominant lines in the composition, with trees and sky forced to conform in their relationships to the abstracted church. My debt to Cubism is clearly evident. Influence by other artists is no bad thing providing it does not descend into copying another artist's work.

DESIGNING WITH CIRCLES

When we are designing within a rectangle it is comparatively easy to organize the picture using straight lines, which easily related to the straight sides of the painting. Not so easy but fascinating, is to design using circles arranged within the picture frame.

Let me make the point that this has little to do with the subject matter. It is just a matter of persuading the subject to conform with a preconceived structure.

An excellent example of this is Tintoretto's, "Origin of the Milky Way", where the composition has evolved using a large number of intersecting arcs of circles.

COMBINING OPPOSITES

Many of my paintings are a combination of opposites. In my figure composition "Male Nude Standing" I have tried to find a compromise between painting an athletic nude male figure and a completely abstract geometric background.

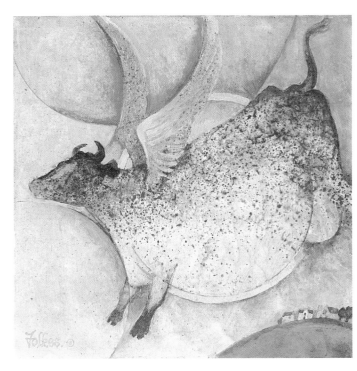

"Pigs Might Fly", acrylic, 9½ x 9½" (24 x 24cm)

An artist friend of mine suggested a title I might like to use: "Pigs Might Fly". Thinking this was an interesting idea, I decided to paint this for the 2000 Exhibition of the Royal Institute of Painters in Watercolour. Members are allowed to exhibit four large paintings and two small ones within a specified longest side dimension. To take full advantage of this size rule I decided to paint a square picture. While thinking how to begin and making trial sketches, it seemed to me that a circle would happily encompass the majority of the cow's body with the segments of circles suggesting the placing of the wings, the chest, the udders, and the land over which the cow was supposed to be flying. The painting was at best a humorous idea and at worst a silly one, but it was given authority by using the carefully designed circles.

"The Virgin and Child"

Many of the Old Masters used triangles as a way of holding a painting of a complex event together. This is a transcript after a painting by Titian which demonstrates the use of a triangle in a way that was common during the High Renaissance in Italy. The triangle leads the eye to Mary's face.

about the artist

Peter Folkes was born in 1923, and studied painting at the West of England College of Art, Bristol. His studies were interrupted by five years of war service in the Royal Corps of Signals.

Although he has painted throughout his career, since retiring as the Head of the Department of Fine Art, Southampton Institute of Higher Education in 1989, Peter has devoted himself to painting full time.

He was elected an Academician of the Royal West of England Academy in 1960, and a member of the Royal Institute of Painters in Water Colour in 1969. He is currently Vice President of the Institute.

Peter has had 17 solo shows in the UK, as well as two in New York. His paintings are in many private collections including the Arts Council of Great Britain and the Royal West of England Academy.

Peter's work can regularly be seen at the Shell House Gallery, Ledbury, Herts; the Manor House Gallery, Chipping Norton, Oxfordshire and the Rowley Gallery Contemporary Arts, Kensington Church Street, London.

"Male Nude Standing", watercolor, 22 x 15" (56 x 38cm)
Working from a life drawing, I explored the rounded muscular forms of this well developed man. Determined to avoid naturalistic coloring and traditional modeling of the limbs, color and tone were used abstractly to exaggerate the forms and integrate them into the geometry of the background. Accents of color and tone were used to accentuate both form and design.

brittonfrancis

abstract shapes hold my compositions together

Although order in a composition is important, order without variety and personal expression can be boring. So, rather than merely describe the physical aspects of a scene or object why not strive to depict the core of your perceptual experience, at the design stage. Study these elements and examples of composition techniques and you will pick up some valuable clues.

Design plans

✔ Make a preliminary pencil sketch.

✔ Use a value plan to help unify the composition.

✔ Decide the format.

✔ Establish the dominant shapes.

✔ Depict the initial inspiration — but include all the essential elements to keep a sense of order.

✔ Create a synthesis of lines, shapes, colors and shape.

✔ Use color to suggest spatial movement.

There are as many ways to design a painting as there are artists who paint them.

A well known artist, whose work I admire, takes a mathematical approach to composition. His preliminary drawings have the appearance of geometry formulae. Other artists prepare a detailed drawing and never vary from the initial plan. Still others reject any preliminary planning whatsoever. They just push paint around the surface until it feels right. My approach to design lies somewhere in between these methods.

Whether I am developing a composition by working directly from nature, sketches or using a photographic reference (usually all three) I will let the work speak to me.

As the design progresses and I begin to see the direction the painting is taking, I will work towards a synthesis of the compositional elements in the painting.

When I was in art college the number one rule was never to place the focal point of a composition in the middle of the format. We were instructed that a center of interest placed off center is more dramatic.

Some art teachers have a set of rules for designing a painting and they insist upon strict adherence to these rules. This kind of dogmatic thinking stifles creative development. There are always contradictions to every rule. Many masterpieces have been created that ignore this rule. Only by trying many different styles and techniques will you grow artistically and develop the compositional style that is most suited to you.

Before I ever pick up a brush, I develop my composition in pencil on paper or with a preliminary pencil sketch on the work surface. This preparatory work establishes a good framework for the design of the image. This does not mean that once a drawing is transferred to the work surface that the pictorial composition is etched in stone. I often make changes as the painting progresses.

HARMONY IN A PAINTING

When you look at a painting, your eye absorbs all the elements of the image simultaneously. For this reason, the sequential order of the composition is important. Order creates harmony in a painting. If certain elements of the painting are out of step, then the viewer feels uncomfortable and it will not hold their interest.

"Forbidden Fruit", watercolor, 20 x 29" (51 x 74cm)

Shown upside down to emphasize the abstract shapes

Rhythmic line

Value plan

RHYTHMIC LINE AND PATTERN

This image is an example of a painting containing both rhythmic line and pattern. The format is divided asymmetrically by two broad divisions of light and dark. Rhythmic pattern dominates the dark area of the bedspread, while rhythmic line dominates the light area containing the sheet and pillows. The angular shape of the plane of light on the bed highlights the shape and color of the apple, (the center of interest), and it also unites the design by creating a passage for the eye between the two larger areas of the composition.

Design plan

There is more to a good value plan than just black and white

A good value plan helps to unify the composition. The scale of grays between and including black can serve as the framework of a composition. Variations in degrees of dark and light can provide an effective way to emphasize the important areas. Light areas in a composition appear larger than dark areas of the same size and shape because of their reflective qualities. Light areas create a passage for the eye to travel from one object or area to another. A good example of this technique can be found in the painting "Forbidden Fruit", on page 57. The arrangement of light and dark values helps to integrate the composition as a whole.

Texture adds variety and visual stimulus to the surface of a painting. Pattern can create rhythm. In the painting "Her Dress", opposite, the patterns on the quilt add visual contrast and rhythm to the painting.

Although order in a composition is important, order without variety and personal expression can be boring. Rather than merely describe the physical aspects of a scene or object I strive to depict the core of my perceptual experience, at the design stage. The test of my success is my ability to convey the initial inspiration while still managing to incorporate all of the essential elements to convey a sense of order.

When I am working on a composition, my primary objective is to create a synthesis of lines, shapes, colors and space. A careful blending of these compositional elements will result in a strong, simple and interesting design.

FORMAT — RESTFUL OR ACTIVE

After I have chosen the subject matter, establishing a format will be the first decision. The format is the shape, size and general arrangement of a painting. A horizontal format tends to be more restful than a vertical format. For example, the overall effect of the horizontal format in the painting "Crystal Cross", page 62, creates a sense of serenity. In the painting "Picture Window", page 63, the vertical format gives the image a more active effect.

Shown upside down to emphasize the abstract shapes

Composition lines

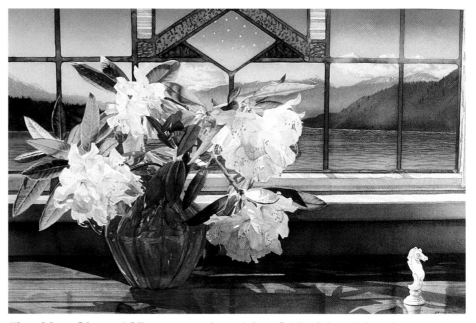

"Looking Glass #2", watercolor, 14 x 21" (36 x 53cm)

DEVELOPING ECHOES IN A COMPOSITION

Echoes are themes or shapes that are repeated throughout a painting. Repetition creates harmony in a composition. The dominant compositional element here consists of a series of repeated vertical and horizontal geometric patterns and shapes. For example, the vase of flowers, (the center of interest), is confined within an implied diamond shape which also appears in the stained glass window. The vase of flowers is echoed by its shadow not only in shape but also by the color contained within the shadow.

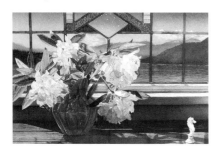

Value plan

"Her Dress", watercolor, 28 x 20" (71 x 51cm)

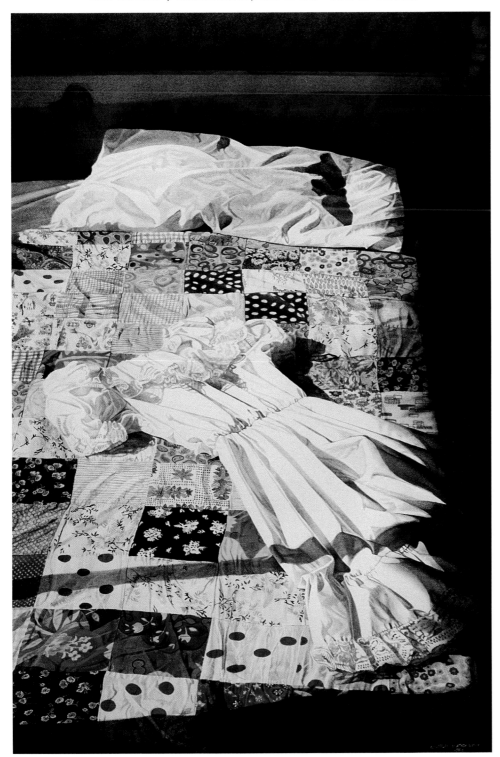

Shown upside down to emphasize abstract shapes

Composition lines

Value plan

PICTORIAL SPACE

The clearest way to indicate space on a flat surface is to choose a fixed vantage point. Viewing from above or below the horizon line is usually more visually interesting. Here, the viewer's eye is placed above the horizon line. The strong vertical thrust of this image would have drawn the eye out of the picture if the vertical direction were not countered by the horizontals created by the headboard and the dark shadows that run across the bed. In this image the simpler shapes of the dress and pillow are contrasted by the visually exciting patterns on the quilt.

Design plan
Creating visual excitement

Color creates an emotional response and visual excitement in a composition. Color also suggests spatial movement. It is well known that cool colors recede and warm colors advance. Harmonious and complementary colors have a stabilizing effect. A complex composition works better with a simple color arrangement. Complex color relates better with a simplified composition.

THE POWER OF SPACE

After determining the format, I start a composition by establishing the dominant shapes. It is the abstract form that the subject or items suggest in a composition that creates these dominant shapes.

Pure abstraction has no recognizable subject. My paintings do include recognizable objects. However, I base my designs on a non-representational abstract construction. This abstract construction consists of geometric shapes in various spatial positions.

For example, a vase and flowers might create an implied circle, or a vase with a flower and two figurines might create an implied triangular shape and the balance of the design could be based on a series of related rectangles. If I turn my painting upside down it helps me to see the composition as abstract without being distracted by the subject matter. Abstract shapes create unity that holds the composition together.

It is impossible to create actual space while working on a two-dimensional flat surface. The challenge for me is to portray an illusion of depth that accurately represents the volume I want to convey in my painting. This is accomplished with the use of such compositional

Abstract shapes

Composition lines

Value plan

"Evening Shade", watercolor, 20 x 28" (51 x 71cm)

SPATIAL TENSION IN COMPOSITION

How you place particular spatial planes and forms in a composition can determine the spatial tension. Spatial tension is created by the implied triangle between the two figurines in the foreground and the circular form of the shade pull. The eye is led by this implied triangle from the elaborate foreground to the impressionistic vista out the window. The shape of the trees, as seen through the window, echoes the line of the flowers.

"Cryptic Crossword", watercolor, 36 x 27" (91 x 69cm)

Abstract shapes

Composition lines

Value plan

ASYMMETRICAL COMPOSITION

In an asymmetrical composition the main area of interest is placed off center and is usually balanced by another, less significant, area of interest.

Here, the center of interest comprises the bird figurine, the glass ball and the silver vessel. All are contained within an implied triangular shape. To create synergy in the painting this triangular composition is balanced with the, less significant, rectangular form of the window. The strong horizontal and vertical lines of the window contrast with the rhythmic curves of the vessel, bird and tablecloth. The rectangular plane of light on the tablecloth echoes the window. The shadows of the objects on the table overlap each other and serve to unify the group.

Abstract shape

HORIZONTAL COMPOSITION

Here, the dominant horizontal composition is anchored firmly within the painting by the vertical line of the candlestick. To emphasize the methodical arrangement of the glass ball, sea horse and candlestick I kept the background of the painting unassuming in form but strong in value. A window just outside of the image casts an intersecting shadow across the tablecloth. This shadow serves to unify the composition. The rhythmic lines of the drapery add variety.

Composition lines

"Crystal Cross", watercolor

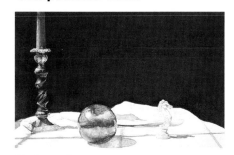

Value plan

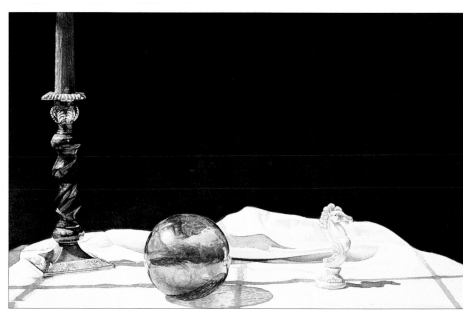

techniques as color, line, shape and directional movement.

Positive space is the area in which an object exists. Negative space is the area immediately surrounding the object. When painting a tree, for example, the space around the tree and the space showing through the branches and leaves of the tree, represents negative space. This is as important in defining the tree as the positive space the tree occupies in the painting. Negative space helps to define the object.

The illusion of depth, movement and the passage of time can be suggested in a composition with the correct use of positive and negative space.

LINES IN DESIGN
- Diagonal converging lines suggest deep space.
- Vertical and horizontal lines tend to flatten space or limit spatial recession.
- The combination of vertical and horizontal lines, used as dominant lines in the composition, stabilizes and unifies the design. This technique is emphasized in the watercolor "Picture Window" opposite.
- Strong directional lines that lead the eye out of the composition should be avoided or counteracted by other means such as an intersecting line that runs in the opposite direction.

- Rhythmic lines create movement in the composition.
- Subjective lines are lines that are visually completed by the viewer.

APPROACH TO DESIGN
Some of the compositional elements I am most comfortable with were used to create the paintings in this chapter.

- Asymmetrical composition.
- Symmetrical composition.
- Horizontal composition.
- Vertical composition.
- Opposing shapes and proportions.
- Rhythmic line and pattern.
- Developing echoes.
- Pictorial space.
- Spatial tension in composition.
- Diagonals in composition.

To sum up, design is just another tool you can use to pursue your own personal vision. There is no absolute right or wrong when composing a picture. I hope I have illustrated some useful compositional techniques that you may want to incorporate in your own paintings. Follow your intuition.

"Picture Window", watercolor, 14½ x 10½" (37 x 27cm)

VERTICAL COMPOSITION

Not only is the format vertical in this painting but the central image, consisting of a vase, flower and the bird figurine, all suggest vertical movement. Combined with the vertical lines of the stained glass window it all leads to a strong image. Stabilizing all this vertical movement in the composition are the diagonals in the window and the horizontal lines created by the windowsill. The rhythmic curves of the lace doily add movement to the design.

Abstract shape

Composition lines

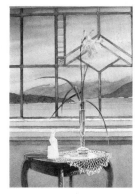

Value plan

about the artist

Britton Francis was born in Vancouver, British Columbia, Canada in 1947 and graduated from the Alberta College of Art in 1971. He was awarded a postgraduate scholarship to the Institute De Allende, Mexico.

Britton has been a full time artist for 25 years.

His work can be found in many collections including the Government of Canada, the British Columbia Government and the Mendal Public Art Museum.

In 1979 he was appointed official artist to the BC Winter Games and executed a trio of lithographs for the Games. His artwork is also included in many corporate and private art collections internationally. He has been the recipient of many awards in international watercolor competitions. He has had over 40 group and solo exhibitions across Canada, and his work has been exhibited in the USA, London and Australia.

Britton's work has been featured in publications and he is listed in the "Who's Who" of British Columbia, Canada. He is on the board of governors and is a signature member of the Federation of Canadian Artists.

He currently resides with his family in Sechelt, BC, on the beautiful sunshine coast. His original paintings may be seen in Vancouver at the Federation Gallery and the Graham Seyell Gallery, and at the Birthplace of BC Gallery, Fort Langley, BC.

I ask questions about format first

You can't compose until you know the boundaries of your support.

The first thing I think about is format — the proportions and size of the support. Long and narrow formats require different compositions than squarish ones. Verticals require yet another mind set. And the size of the support must be taken into consideration when considering the complexity and ambition of the subject. I've ruined potentially good paintings by simply choosing the wrong canvas size.

I find that if I study my reference material or the subject at hand I can see the size and proportions that will work best. It's important not to have a certain size canvas around the studio and then try to find something to fill it up. I have a large variety of sizes and shapes ready to go at any time. I let the subject make the decision for me. When a subject has strong verticality I find a square or even vertical canvas works best.

Design plans

✔ Decide on the format.

✔ Make small sketches to head off composition problems.

✔ Watch out for the "baddies" (unfortunate lineups, uninteresting areas, equal size objects and spaces).

✔ Keep an eye open for the "good guys" (helpful elements such as rocks, trees, water, metaphors, potential syntagmas, or repetitive sequences, anthropmorphic interest, i.e. suggesting human shapes).

✔ Find angles or echoing shapes and lines.

✔ Look for interlocking gradations and add energy with spotting.

✔ Use anything that adds unity.

On the other hand subjects with strong horizontality can take the longer formats without looking too "kitchy".

PLAYING WITH IDEAS

I start my compositional planning with my reference, either in the field or at the light-table. Very often something will just catch my eye and it will seem right. I frequently play with three or four composition ideas before I start to paint. Sometimes I do little soft pencil roughs about the size of postage stamps. I purposely don't do too much on these because I want to save my energy and interest for the work itself. The small sketches nevertheless tend to head off compositional problems that may lie ahead.

THE STUDIO PROJECTOR IS AN AID TO COMPOSITION

Out of focus on a white surface a slide thrown by a studio projector quickly shows a scene's weaknesses and strengths.

I look for pattern and I pay particular attention to how the darks impinge on the edges of the support.

In my studio work I tend to mix and match compositional elements and I often commit myself to one in order to find out what the next will be. Slides work well because you get twice the reference material than with opaque media like photographs. A seagull, for example, can be made to fly to the right or to the left simply by flipping the slide.

I use the projector to lay in difficult parts such as faces, hands and other complex and challenging passages. It's important not to become a slave to the projector. It's a great time-saver for compositional planning but it's my servant and I dismiss it early.

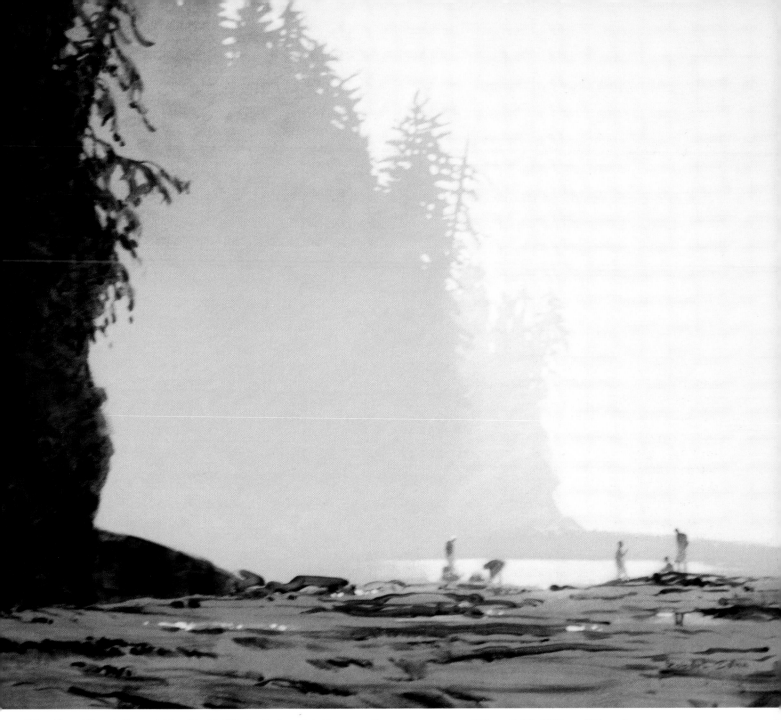

"On the West Coast Trail, British Columbia", acrylic on canvas, 30 x 34" (76 x 87cm)

A low horizon emphasizes the mass of the sea-cliff edge and the intervening mist, which is the subject of the painting. I seldom use figures in landscapes but added them here to give the cliffs scale. These are my hiking companions. The tall figure on the right stops the eye from heading off canvas.

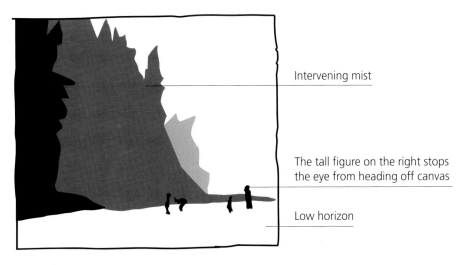

Intervening mist

The tall figure on the right stops the eye from heading off canvas

Low horizon

"Near Chance Harbour, New Brunswick", acrylic on canvas, 16 x 20" (41 x 51cm)

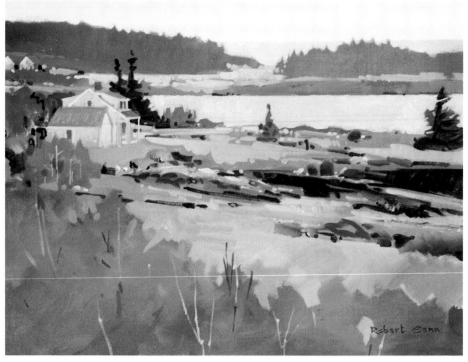

This has a high horizon line with a well decentralized center of interest almost pushing against the edge. The foreground is cursory and unfocused. At the top of the painting, very near the middle, a gap in the dark blocks of trees lets the eye out to the sea.

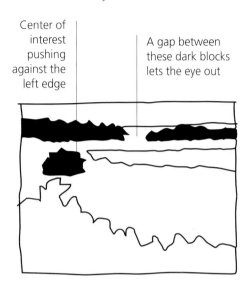

Center of interest pushing against the left edge

A gap between these dark blocks lets the eye out

Design plan
A fast and easy way to pull weak compositions together

Glazing, particularly with acrylic, is a fast and easy way to pull compositionally weak paintings together. Whole paintings can be made slightly or much darker with an overall wash of any number of tones. My current favorite is Phthalo Blue, well diluted with water and acrylic medium. I put it on with a rag and wipe it off to the desired level of tint. After the glaze is dry, the sky, snow or other elements can be punched back in to regain the compositional strength.

Glazing is also highly valuable in finding and defining the center of interest, focus of light and the painting's area of climax. I consider composition more important than color and, because I'm relatively casual with color, glazing has been my salvation.

WATCHING OUT FOR THE BADDIES

I am a strong believer that paintings ought not to be what is seen but rather what is to be seen. In this sense I almost never paint anything as it actually exists. I agree with Whistler when he said that nature is usually wrong. Outdoor work demands that I remove, change and add elements to make the work satisfying.

I particularly look out for unfortunate lineups, amorphous zones, equal size objects and spaces, and other baddies.

On the other hand I search for design elements in rocks, trees, water, whatever, and further anything that might suggest anthropomorphic interest (suggestive of human shape or character), metaphors, potential syntagmas (repetitive sequences), and so on.

Further, without making it too obvious, I try to find possible angles and echoing shapes and lines that might help to strengthen and unify the design. I often go to some trouble to continue and embellish precious curves in order to gain eye control and add fluidity.

"On the Duoro, Portugal", acrylic on canvas, 16 x 20" (41 x 51cm)

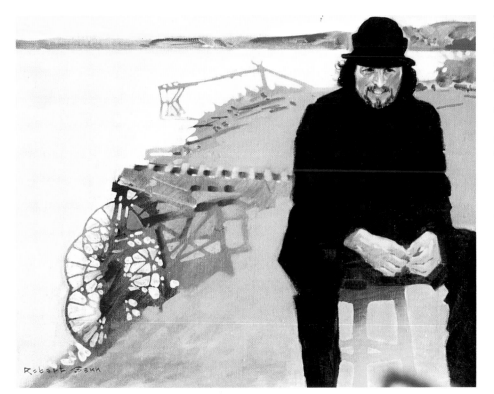

This is a very decentralized pattern of a man operating fishing devices along the river edge. Very often I insist that the horizon line goes through the subject's eyes in order to create presence. Here, by placing the eyes below the horizon, a more informal feel is achieved and the simplicity of a snapshot is kept. Several other lines in the composition point and direct the viewer to the face. The circular hat and wheels echo each other.

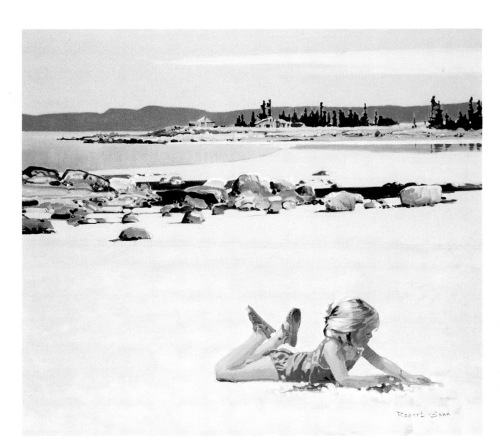

Two main background patterns move knifelike to contrast with the animation of the single playing child. All this is set in the negative area of the sand, which is essentially the same tone and which does not lay flat except where the water makes it do so. The single cloud echoes the design motif and the horizontality of the scene.

"A Great Big Wonderful World, Whaling Station Bay, Hornby Island, British Columbia", acrylic on canvas, 30 x 34" (76 x 87cm)

**"Near Riviere du L'Ouelle, Quebec",
acrylic on canvas, 11 x 14" (28 x 36cm)**
This was essentially an exercise in interlocking patterns designed to hold together and create the illusion of the forest edge. Minor interlocking gradations and contrapuntal color add close abstraction to an otherwise realistic composition.

**"Forest Edge in Brown and Black",
acrylic on canvas, 16 x 20" (41 x 51cm)**
Similar-in-hue forms are interwoven in an abstract pattern. The counterpoint of snow and light sky sets the parameters. The simple composition is held together with a maximum of verticals and a minimum of diagonals.

My compositions are "spotty". That is, I try to build up a design by adding spots of dark and light.

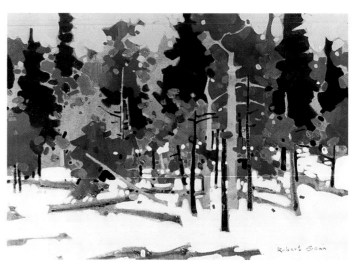

Design plan
The Rule of 360

A small percentage of my work is done on location. Very often the view that brought me to a halt is not the one I will paint. I use what I call the "Rule of 360". That is I slowly turn myself 360 degrees to see if there's something else that's better. If I'm in the mood, I can often find two or three alternatives.

I think field sketches should be fun and fast with a bit of *bravura* in full knowledge that they can be pulled together later. This may be due to a certain intransigence on my part. I think I know the compositional rules, I feel I can break them, and I feel I can pull some of them together when I'm back at the studio base. I seldom complete field work on location. I like to look at them again in the cold gray light of dawn in my studio and I actually derive pleasure from burning inadequate or failed efforts.

WORKING WITH SYMMETRY AND MONUMENTALITY

While the classical rules of composition have altered and changed over the last century, I'm still interested in formal and traditional compositions as well as breaking some of the rules. There is a far greater sense of play in modern composition. I'm interested in my own nuances of design but traditional elements such as symmetry and monumentality still have their place. It's a sort of controlled organization of shapes and sizes that lends a holistic and simple unity to the composition. At the same time I like a degree of serendipitous happenstance, a kind of non-academic indulgence. This seems to me to add interest but it may also serve to keep me amused and at it.

Since Japanese prints, Degas, and the snapshot photograph, the shibboleths of composition have been less important. Figurative work, particularly, is now vastly more interesting because of this relaxing. Subjects stress against the edges and, at times, look out of, not into the picture. I like my figurative work to sometimes look like a *tableau vivant* in progress. A face in front of a face, or a goose looking the other way, do not bother me.

"Metis Beach, Quebec", acrylic on canvas, 16 x 20" (41 x 51cm)

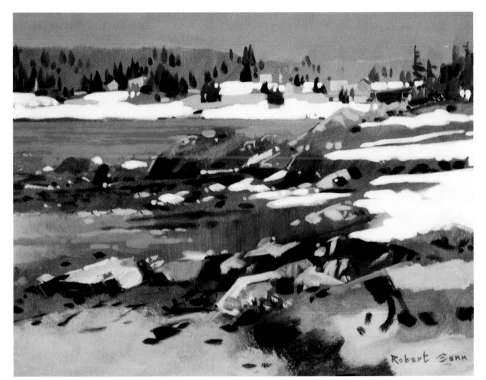

A high horizon line permits teasing in the foreground. The eye is led back through the patterns of receding snow characteristic of early May. An area of defocused dark in the immediate foreground gives eye control and invites the eye toward the more crisp middle and distant ground.

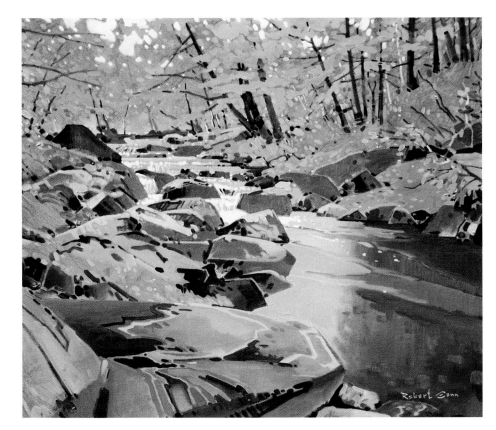

A combination of form and formlessness adds abstraction to the composition. I like my paintings to read realistically from a distance and be interesting to look at up close.

"Goldstream, Vancouver Island",
acrylic on canvas, 30 x 34" (76 x 87cm)

"Wenkchemna Peaks, Moraine Lake", acrylic on canvas, 16 x 20" (41 x 51cm)

Mountain snow gives a terrific opportunity to play with pattern. Here, I put in the snow first, working out lineups and areas of potential gradation. The whole painting is busy and stacks up and out in all directions. Lost areas and lines tend to give mystery.

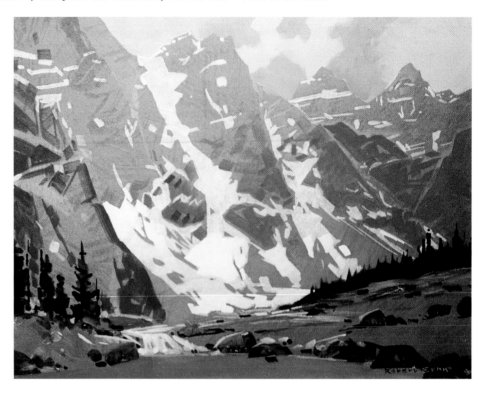

Design plan
Foreground thinking

The foreground is a most important part of the painting. I often put myself into what I call "foreground thinking". This is done on location or at the light-table. If the foreground can be established and properly designed then the background can be fitted and nudged to work with it. As I said before, I don't mind taking liberties with the truth. When I come to the sky — and I frequently leave this till near the end — I am in the area where a maximum of variety can take place. Constable said that the sky was the principal actor in the painting. This is where I most often complete and control the design and mood of my composition.

UNIFYING DESIGN WITHIN LIMITS I SET

Landscape painting tends to fall under more academic controls. I must say I often like working within these controls. It gives me the feeling that I'm taking part in a noble tradition. Orson Wells said that the greatest enemy of art is the absence of limitation. I find with my personal style my compositions work best when I try to build pattern within the limitations I set for myself. At the same time I try not to let go of the little habits that give me pleasure and have become the elements of my signature. For example, I believe in interlocking gradations and generally a gradation in a large area. I hold areas in counterpoint if I can in order to suggest a sort of formalized and painterly dance. Further, I often like to add energy and activity with a kind of spotting which, for me, tends to unify the work.

This unity is perhaps the most important thing I watch for and it's the place where I most often fail. I use several techniques to get my compositions to hold together. This includes looking at work-in-progress with half-closed eyes. More often than not it means relegating the work to a secondary easel.

**"The Last of Ninstints, Q.C.I.",
acrylic on canvas, 30 x 40" (76 x 102cm)**
There is jumpy activity throughout in counterpoint to the hazy and shadowless day. The verticality of the totems was emphasized by the squarish format and contrasted by foliage sweep. I wanted the poles to look heavy and yet be dominated by the encroaching forest.

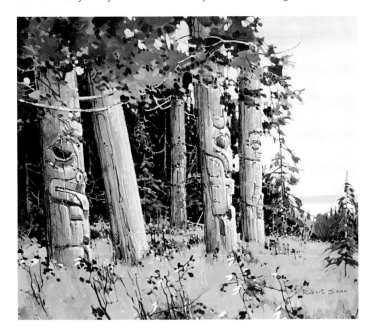

**"Village on the Tarn, France",
acrylic on canvas, 11 x 14" (28 x 36cm)**
This sketch was mainly an opportunity for pattern. I'm a bit embarrassed about it but I often look at something and just feel I must inflict my style on it. Tight to edge cypresses keep the verticality of the little thing going.

I often make up compositions as I go along. I started with the mirror image of my face and hands. When I saw they were okay I put in my airedale, whose name is Emily Carr. Then I added the studio around me.

**"Self Portrait with Emily Carr",
acrylic on canvas, 24 x 30" (61 x 76cm)**

"Oranges of Portugal",
acrylic on canvas, 24 x 30" (61 x 76cm)
The central characters and boats, essentially in silhouette, give this composition a monumental feel, as does the absence of impingement on the edges. I paid quite a bit of attention to designing the negative areas around the elements. My object was to make a simple, what I call "1,2,3,4", composition.

"Selkirk High",
acrylic on canvas, 11 x 14" (28 x 36cm)
A typical monumental field sketch based on a feeling of exhaltation — or reaching toward the sky. The tree peaks echo the mountain. Foreground energy is held by the device of enveloping mist.

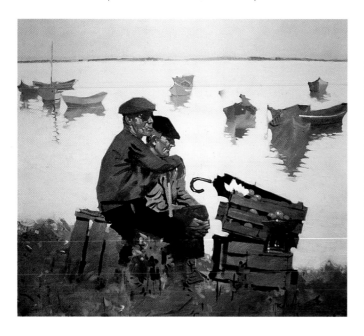

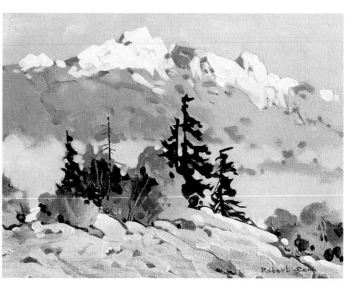

Design plan
Use the best references

I think it's important to work from excellent reference which has been gathered by the artist — one who is fussy about light, detail, organization, and so on. This is a professional activity in its own right. Perhaps it's also important to do a certain amount of work on location with a sense of joy and play. Further, I think it's valuable to simply make some works directly from the imagination. A few early morning splodges on an otherwise unplanned canvas will often lead to a decent work for the day. It's a gambit — one compositional element suggests and asks for another. This is what makes the activity interesting. As the lady said "How do I know what I think until I hear what I say?"

CRITICAL ANALYSIS

The use of the secondary easel is basic and vital to composition. Critical judgment takes place in a relaxed manner, often with the help of the dog, a cigar, and a glass of scotch. Temporarily framed but unfinished paintings are now under the eye of another ego. Things I thought I had to do, I now don't have to do; and things I didn't know I had to do, I have yet to do. Generally there's less than I thought. It's better to leave them ten percent unfinished than to overwork them one percent. The main thing is the "big picture". If it's not there it's sometimes impossible to fix.

It's the balance between planning and serendipitous evolution. Eisenstein, when asked to comment on how to make films, said, "Careful planning and brilliant improvisation".

"On the Temple Grounds, Kyoto",
acrylic on canvas, 12 x 16" (31 x 41cm)
The white walls pressing through the trees, and the design formed by the knot of novitiate Buddhists ready to go on a guided tour, was what interested me here. A low horizon gives majesty to the building and the ancient pines bring an amorphous texture to the composition.

"Crescent Park in Winter",
acrylic on canvas, 16 x 20" (41 x 51cm)
I've tackled this subject quite a few times because it's only a mile away from my studio. This is an illusion created by a pattern of pure white snow and gradated, partly iced water. Lines radiate from a point "off screen" and provide serendipitous eye control.

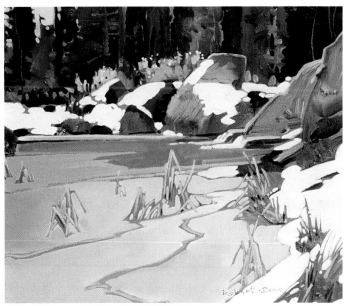

about the artist

Robert Genn was born in Victoria, British Columbia, Canada in 1936. His formal training included courses at the University of Victoria, the University of British Columbia and the Art Center School in Los Angeles, California.

Recognized as one of Canada's most accomplished painters, Robert Genn has become well-known internationally. While his subjects are universal, he has painted on location in many of the globe's distant corners, he excels in portraying Canada, and in particular his work on Canada's west coast and in the Rocky Mountains has received acclaim.

Robert Genn's technique includes a tradition of strong design with harmonic patterns of color and form. His personal style is unmistakable. Grand themes are transposed onto small panels and canvases in a manner similar to the members of Canada's Group of Seven. His large paintings are unique monuments which honor Canada and have formed an important part of the cultural heritage.

His autobiographical book "In Praise of Painting" provides an insight into the progress and trials of a Canadian painter. Other publications include "The Dreamway" and "The Painter's Keys".

As well as work in acrylic, oil and watercolor, Robert has produced more than 100 limited edition serigraphs. These low-edition works, using the silk-screen process, are created by an all-hand method which lends itself to his individual style.

His work also reaches a wide collectorship through a series of photolithographic prints. His paintings and reproductions are found in major collections throughout North America and Europe.

His work has been featured in *International Artist* magazine. Robert is also one of *International Artist* magazine's International Painting Workshop Vacation teachers.

kiffholland

I compose my thoughts first

Drawing is the intellectual part of art and painting is the emotional part. When both these elements come together, we have a satisfying painting.

When I was eight or nine, I filled drawing books with action pictures of battleships under attack, galleons with pirates plundering and steam locomotives with engineers guiding them through wild mountain passes. The pages were filled with vital information; exploding shells, cannon, aircraft, connecting rods, whistles, rat lines, blocks and tackle, jolly-rogers, eyepatches and shouts of "Yo-Ho-Ho". There was a lot going on.

Composition? I had not heard of it.

These days composition is the primary tool I use to show the viewer what I see, to let them feel something of what I felt and to make a spiritual connection through a work of art.

When I compose a picture this is what I think about:
• What is it that drew me to the subject?
• Does this subject have the essence of universal appeal?
• And, more importantly, can I draw it and communicate my message?

The next consideration is how the subject should be seen:
• Should the format be vertical, horizontal, round or triangular?
• Where should the light be coming from?
• How big should the subject be in the space? Large — to create a powerful, intimate, singular work? Small — and we have a lonely, expansive piece?
• Where do I place the subject in the format I have chosen?
• What ancillary material do I need to enhance the mood?
• What should the sitter wear (or not wear)?
• Is it to be a drawing, etching, painting, a serigraph, or does it cry out to be a wonderful sculpture?

You may find the following bits of information helpful.

MY METHOD

Having decided what to paint, considered where best to place the subject, and what other "things" I need to enhance the subject and where to place them, I then start drawing, being undaunted by errors that I correct along the way.

Color is equally important. Color creates, enhances, changes, reveals and establishes the mood of the painting.

Earth colors are warm and inviting — but they are also the colors of conflict.

Cool colors on the other hand can be cerebral. They can also be used as symbols of alienation.

In short, color used in the right combination is as important as placement in constructing a painting.

I think drawing is the intellectual part of art and painting is the emotional part. When both these elements come together, we have a satisfying painting.

Design plans

Before you do anything take a little time to consider how the subject should be seen. Decide the following:

✔ Format Shape.

✔ Light Source.

✔ How big the picture should be.

✔ Placement.

✔ Ancillary material.

✔ Mood.

"Side Show", oil, 40 x 60" (102 x 152cm)

Winter, New York, Washington Square. I know, I know it should be called "Pretty in Pink" and I know she is adorable, but I want you to see past her to the phalanx of spectators. They are fascinated by the artistry of the performers who are "off stage". I have contrasted this group with the two groups walking across the canvas, together they form a rhythm of people connected by their shadows. The only anomaly is the little girl — she breaks the rhythm. She is a focal point three times over, through color, through being the only child, and because this composition is based on the golden rectangle, her head is where the diagonal cuts the square. (I love her sneakers).

VALUES REVEALED

This version shows you the importance of the light and darks in the painting.

DESIGN ELEMENT

Light
Color
Contrast

ARRANGEMENT OF SHAPES

Three distinct groups connected by shadows. Think of design as stage management.

"Peaches and Plums", oil, 48 x 48" (122 x 122cm)

At times some subjects cry out to be big! I have painted this sand moulded plate with its quirky symmetrical pattern many times but could not do justice to its artistry. Looking down on it the plate on the white table cloth seemed to be a calming mandala. The fruit form a rich center for the double image of plate and cast shadow. Symmetry is created.

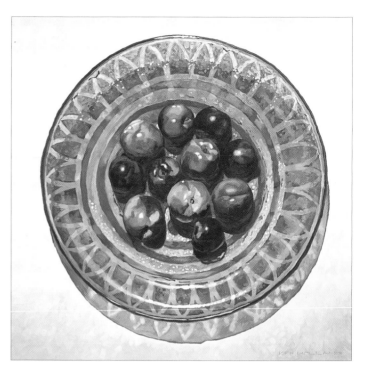

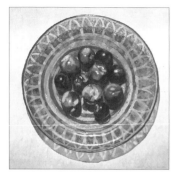

Value plan

Symmetry

DESIGN ELEMENTS

Value plan

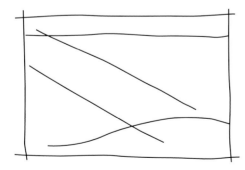

Shape plan

DESIGN ELEMENT

Eyepath strategy

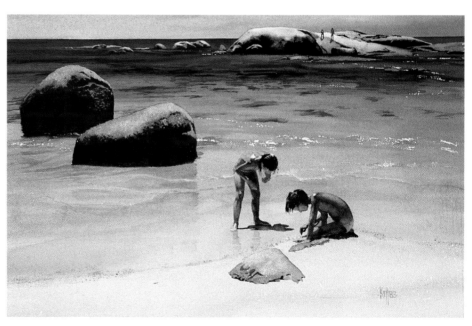

"Boulders", watercolor, 16 x 22" (41 x 56cm)

Beaches are a treasure trove for kids. Sometimes they find the most extraordinary things, much to the consternation of their parents. The diagonal created by the kids and the boulder . . . leads out of the picture — oops! But I hopefully bring you back with people on the far rocks. They form a barrier against the pounding surf. I allowed the gentle waves to carve lazy S-shapes in the pristine sand.

"My Home", watercolor, 28 x 40" (71 x 102cm)

Painted in 1990, this was a response to the politics of apartheid in South Africa. Not only was it a separation of blacks and whites, it was also a separation of blacks from their families. The symbolism in this classical composition shows the woman's family trapped in the wall, separated from her. The unlit lamp signifies a lack of hope. She looks out at us with frustration and resignation. (This painting won the Emily Goldsmith Award at the A.W.S. Show of 1991.)

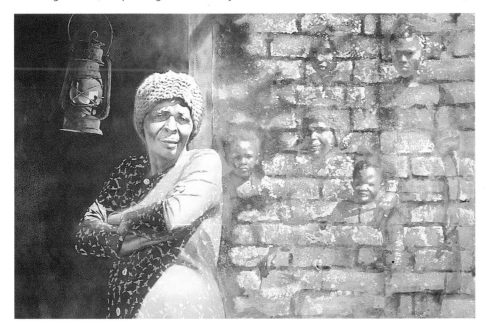

DESIGN ELEMENTS
Symbolism

Value plan

Division of shapes

DESIGN ELEMENT
Color
Shapes

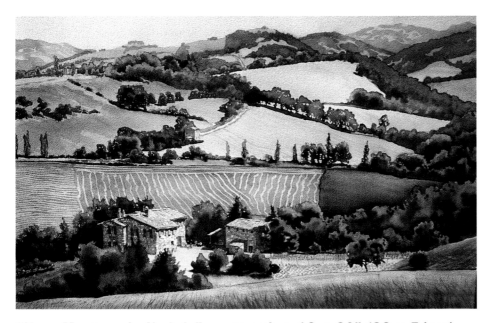

"Near Montone in Umbria", watercolor, 13 x 20" (33 x 51cm)

This is a classic composition based on the golden rectangle. The focal point is the farm, situated on the intersection of the square and diagonal. European hedgerows are natural pattern makers, leading your eye across the landscape to the next farm, nestled in the trees. The importance of the farm in the foreground, with its light dappled roofs and heat baked yard, is enhanced by the vigorous contours of ploughed fields around it. As we look towards the horizon the details and colors become muted. I have, however, warmed up the color at the top of the yellow fields, to give a sense of greater incline. Similarly, the hill just left of center has a warm crest to give the illusion of being higher than the cool valley just below it. This is a landscape, the sky is therefore just a sliver at the top of the picture.

DESIGN ELEMENTS

Contrast

Line

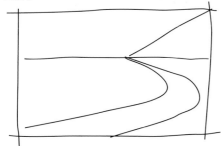

Value

Line

DESIGN ELEMENTS

"Valley Farm", watercolor, 16 x 24" (41 x 61cm)

Sometimes the landscape is wonderfully right. I hardly moved anything around in this scene. The slow moving stream leads naturally to my focal point; the farm. The barn is the most prominent of the farm buildings where the darkest dark is set against lightest light. Notice how light the yellow is around the farm building. All the other colors are tints or tones. The foreground, with detailed grass stubble, naturally draws one forward. The strong band of mountains, forest, and farm buildings create a peaceful, crisp, winter's day.

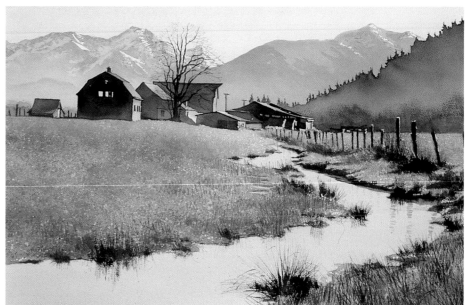

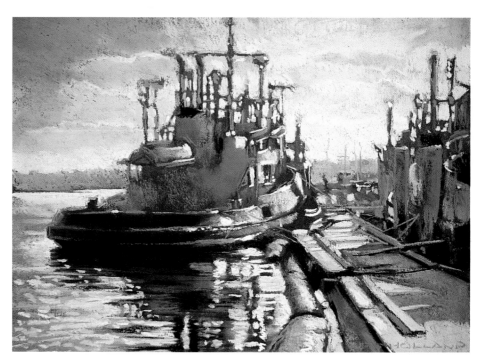

"All Tied Up", pastel, 13 x 17" (33 x 43cm)

Docks, with the continuous coming and going of people and boats; the noise of winches; seagulls; the creaking wharf as the tug rubs against it and the slop-slosh of the water invite you to walk down this wharf to take a closer look. I've allowed you safe passage between the two masses of boats — to eventually enjoy the distant shore.

78

"Roses, watercolor", 16 x 24" (41 x 61cm)

Shade and shadow are the mainstays of this composition. I was fascinated by the softness of the cast shadows and the immediate shadows cast by the objects on the table. Roses are not easy to paint so to be safe I allowed most of the color to happen on the shade side of each flower. The diagonals made by the roses are balanced by the diagonal shadows running the other way.

DESIGN ELEMENTS

Shadow
Diagonals
Value

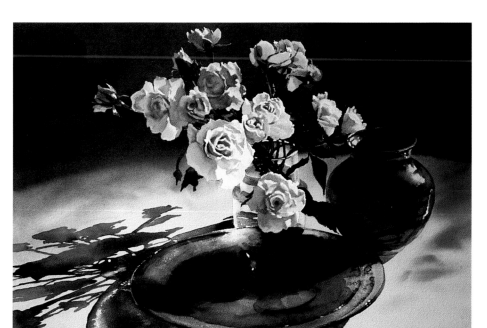

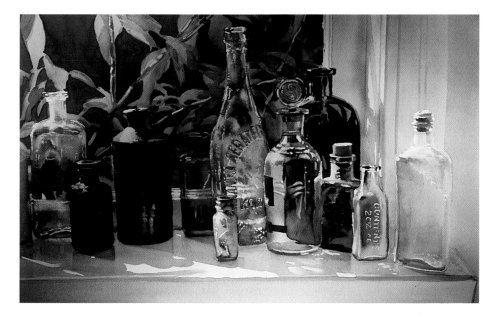

about the artist

Kiff Holland was born in South Africa and now lives on the edge of the forest in North Vancouver. Kiff received his formal art training at the University of Witwatersrand and the Johannesburg School of Art. On immigrating to Canada in 1975, he was immediately captivated by British Columbia's soft color and light. In 1992, Kiff became a signature member of the American Watercolor Society. He won first prize in the 1993 Societe Canadienne de L'Aquarelle in Montreal, and was recipient of the annual Gold Medal Award from the Federation of Canadian Artists in the same year. Kiff is a past president and senior member of FCA

He teaches in the Design Illustration department of Capilano College and has conducted workshops in France as well as Canada and the USA.

In addition to those countries, his work has been exhibited in Britain, South Africa, Mexico and Australia.

"Old Bottles", watercolor, 13 x 20" (33 x 51cm)

Old glass, with its imperfections, old handwritten labels, self advertising on pop bottles fascinates me and I have been collecting it for many years. This was painted at a friend's home. She has the appropriate wooden windows with wide glossy sills to accommodate my latest finds. The main focus was created by overlapping the bottles on the right. I then quietened things down by making the outside edges less busy. The leaves create a natural foil for the rest of the scene, which is man made.

tom**huntley**

my 5-point plan

Let me show you how following a simple 30-minute design plan lets me put more of me into my creations.

I can remember my first drawing instructor telling me to develop total hand/eye co-ordination, bypassing the mind completely "so the hand records what the eye sees". It didn't occur to me at the time, but the more finely our hand/eye co-ordination is tuned the more capable we are of recording or portraying our creative thoughts.

Artist, Kimon Nicolaides, once wrote, "We rid ourselves of the tyranny of objects as they appear, slavishly recording things and shapes as they occur in a camera discovered composition". This is a delightfully freeing thought. It invites us to be creators, not recorders, and to involve more of ourselves in our artwork. It offers us the fulfillment of being creative artists. How we accomplish this is as unique as our fingerprint. Let me tell you how I go about the process.

Design plans

✔ I find the right point of view.

✔ I develop a value study.

✔ I determine the color scheme.

✔ I determine the medium.

✔ I ask — if there is something I can add to make a stronger statement.

HOW DO I INJECT MORE OF MYSELF INTO MY CREATIONS?

It all starts with my choice of subject. When I see something that inspires me, I am faced with the choice of recording what I see or interpreting what I feel.

It is always fun to jump right in and start splashing away, confident that the Divine will intervene and, magically, a masterpiece will appear. However, a direct line is not always the most appropriate path.

I designed the following 5-point planning procedure to help me get closer to my goal. Using this procedure I explore each phase of my creation. The important thing is that the decisions I make along the way give my painting a touch of my personality.

This is my plan: I find the right point of view. I develop a value study. I determine the color scheme. I determine the medium. Then I ask — if there something I can add to make a stronger statement

I follow this procedure before the final painting begins. It should not take more than 30 minutes. Some people believe that this much planning creates the danger of losing spontaneity, I find just the opposite. It is a liberating exercise, that allows my learned skills and my imagination to mingle and create something new and original; as unique as my signature because, in a sense, it is my signature.

I'll expand on my procedure, using my painting of a tractor as a case study.

1. I FIND THE RIGHT POINT OF VIEW

Choosing the right point of view involves walking around the subject, either physically or mentally, and viewing it from every angle — from ground level and from above. I try to discover the special something that attracted me to the subject in the first place. At this point, I fantasize a conversation with the subject:

QUESTION: What is about you that makes me want to show your uniqueness to the world?
ANSWER: It is the burnt red rust of my pathetic old discarded carcass that pushed your nostalgia buttons.

QUESTION: What is the best point of view to show you off? Up close, middle or distant?
ANSWER: Close enough to show my rust and wrinkles. I always wanted people to look up to me.

QUESTION: How much background will I need to capture the mood?
ANSWER: Little or no background, just enough to make a statement about my location.

These few questions give me sufficient information to establish my point of view, and the probable cropping. You will note that there is more linear detail in the "point of view" sketch than in the value sketch. I am still thinking THINGS and not shapes at this stage.

Design plans in action

The tractor was the main subject of this painting, but when I looked at the finishing painting I decided it needed something more — a stronger statement.

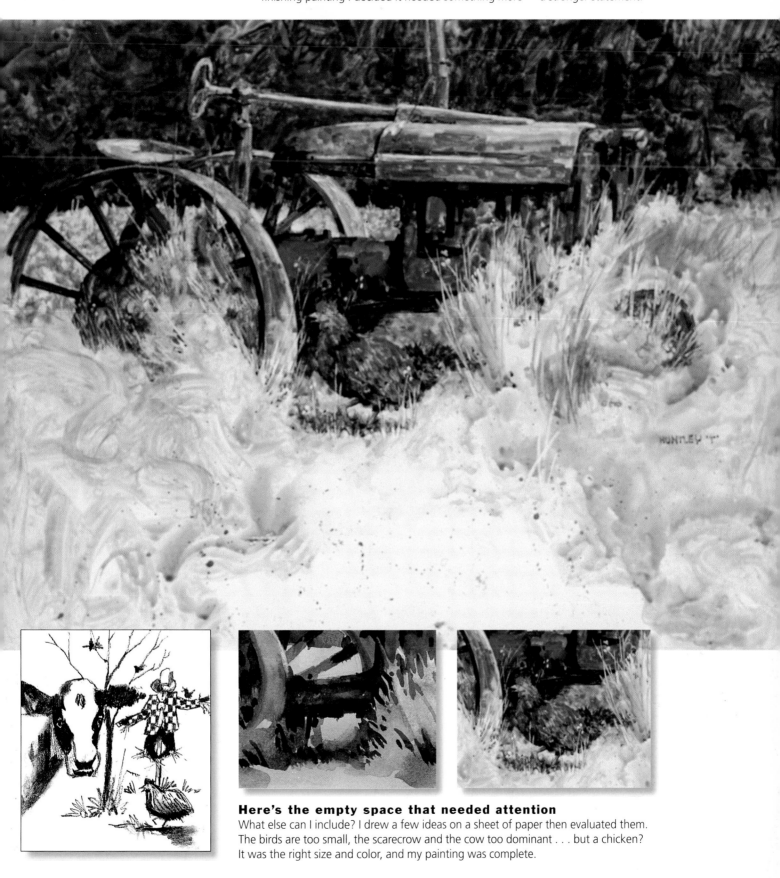

Here's the empty space that needed attention

What else can I include? I drew a few ideas on a sheet of paper then evaluated them. The birds are too small, the scarecrow and the cow too dominant . . . but a chicken? It was the right size and color, and my painting was complete.

point of view as a design plan

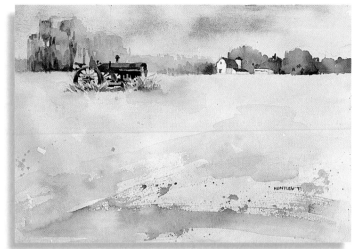

DESIGN PLAN

Find the right point of view

At this stage I think THINGS not shape.

After carrying on my imaginary conversation with the subject I made four different color studies.

Here's how I might have developed the point of view ideas

You see how a few minutes thinking about the subject gives you several possibilities. Each of these little studies has merit.

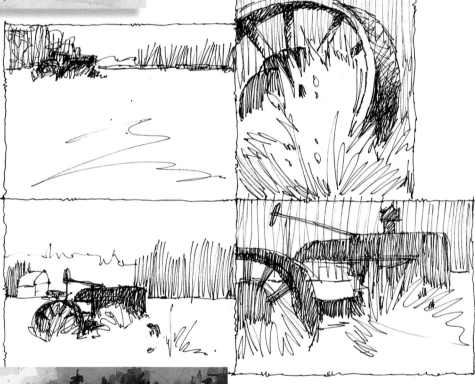

Preliminary sketches

These elementary sketches gave me four options. Each is from a different viewpoint showing the tractor and the details in a different scale.

DESIGN PLAN
Choice of medium

Choosing a medium, or a mixture of mediums, that best fit the demands of the subject is as important as the choice of palette.

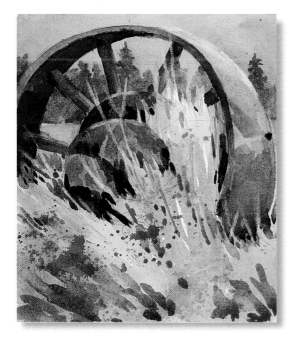

DESIGN PLAN
The color scheme

Having opted for watercolor on plate finish watercolor board, I selected the palette. Color choice says more about you than any other choice you make.

I decided on "wrinkled rust red" to support the nostalgic mood I wanted for this piece.

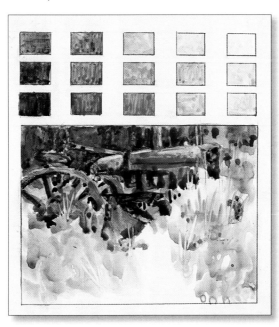

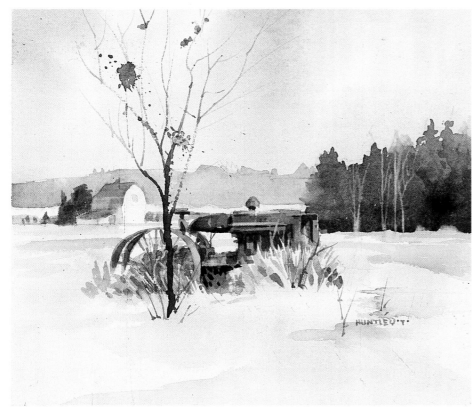

You discover many possibilities when you work this way.

DESIGN PLAN
The value studies

Here I think SHAPE not things.

Each of the big shapes is made up of secondary shapes and negative shapes. Using these, I focus on locating the focal point, by creating an entrance way into the painting and controlling the eye movement within the picture area.

"Brutus", pastel

1. Point of View
Looking up at a dog makes him seem noble.

2. Abstract Study
In this abstract you quickly see how the patch shapes fit into the rectangle.

3. Color Scheme
By using a light shade paper for the background I was able to produce a strong edge. Mid tone, darkest dark and lightest light are all represented.

4. Medium
Pastel chose itself here. The velvety blacks are perfect for quickly capturing the subtle shades in the dog's coat and defining the furry edges.

5. Stronger Statement
The contrast of the strong diagonal of yellow behind the dog accentuates his profile.

2. I DEVELOP A VALUE STUDY
Eduard Manet said, "There are no lines in nature, only patches of color side by side". It is these patch shapes that I fit into our rectangle, the painting format.

Giving all my attention to shape and design, I begin with the big shapes, not concerning myself with things. In my point-of-view sketch, there are four basic shapes: two background, one middle ground and one large foreground shape. By varying the value intensity of these big shapes, in two or three thumbnails, I can quickly determine balance and relative importance — the first step in the visual concept of the value pattern. Each of the big shapes is made up of secondary shapes and negative shapes. Using these shapes, I focus on locating the focal point, by creating an entrance way into the painting and controlling the eye movement within the picture area.

It is in developing the values studies where I first concern myself with creating the illusion of depth, by overlapping shapes, dark and light contrasts, and lost and found edges. To express my vision accurately, I want to choose the best combination of these elements.

3. I ESTABLISH THE COLOR SCHEME
Each step in this procedure, including the color sketch, is done quickly, developing and determining thoughts using artist's shorthand.

In my fantasy conversation with the tractor I agreed that "wrinkled rust red" and a nostalgic mood were inspirational factors.

Of the four basic color schemes available to me — monochromatic, analogous, complementary (or split complementary), and primary — the analogous and/or split complementary appear to be a good choice. The local colors of the subject, (red and green, with warm and cool complementary characteristics), support this decision.

1. Point of View

I tried to avoid strong perspective lines in this painting. Anyone who has been to Granville Island in Vancouver will know how it is dominated by the structure of the massive bridge that passes nearby.

2. Value Study

In this mono version you can see how the lightest light focuses attention on the crowd strung along the deck of the wharf.

3. Color Scheme

The primary colors in this picture quickly determine the festival atmosphere so characteristic of the Granville Island markets.

4. Medium

I chose acrylic here because it suits both the primary color scheme and the flat perspective I wanted to capture.

5. Stronger Statement

I emphasized a number of elements to bring this design together. The piles of the wharf, the repetition of the triangles in the roof and bridge trellis. Also the strong diagonals in the background under the bridge. Notice how I left the white of the canvas for many of the figures.

"Granville Island", acrylic, 14 x 20" (36 x 91cm)

To give me the desired results for the analogous color scheme I chose a palette of yellow, red and orange, in respective shades and tints. The same scheme was used for the split-complementary with the addition of blue. (I chose Yellow Ochre, Burnt Sienna, Cadmium Scarlet and Phthalo Blue.)

When I combine my color scheme with my value study, the work of art begins to take life. Each decision I make has helped create a more personal and unique interpretation. The choice of colors says more about me than any other choice I make.

4. I DETERMINE THE MEDIUM

The choice of medium and the technique used in the application, sets the stage for choices and decisions. I want to use the medium that accentuates my subject. That is, the technique that would best show off the textured, red rust. For this painting, transparent

1. Point of View
I see this as a portrait, rather than a still life.

2. Abstract Study
The bright shine on the face of the pumpkin becomes the focal point.

3. Color Scheme
I juxtaposed patches of blue with the complementary orange of the pumpkin.

4. Medium
Transparent watercolor seemed perfect for the bright crisp effect I was trying for.

5. Stronger Statement
The earmuffs and cap on the pumpkin take what might have been an ordinary still life into another dimension.

"First Snow", watercolor, 15 x 22" (38 x 56cm)

1. Point of View
By cropping off the top of the head the viewer seems to get up close and personal with the subject.

2. Abstract Study
A mono version of this painting would show how almost all the darks are joined into one continuous form thereby unifying the elements.

3. Color Scheme
The limited palette used here gives a monochromatic feel.

4. Medium
Blending strokes is done most effectively with pastel.

5. Stronger Statement
The subject is turned away from the light source rather than the usual reverse pose.

"Harry", pastel

watercolor on "plate finish" watercolor board were selected because they would meet all my requirements.

Choosing a medium or a mixture of mediums that best fit the demands of the subject is as important as the choice of palette. Leonardo da Vinci said, "Everything is related to everything else". The relationship between each phase of the plan determines the degree of success of my creation.

Developing and following a plan offers the opportunity of injecting more of me into my work.

5. I ASK IF I CAN MAKE A STRONGER STATEMENT
What can I do to my composition to make it say more? There is no wrong time in the planning process to ask this question, as the creative thought can come at any moment. For example, I first thought the composition needed life when I was doing the value studies; the most

abstract part of the planning process. However, I like to ask the "something extra" question towards the end because whatever I decide should enhance the initial concept, not replace it.

I run through snippets of "life" ideas . . . the bird is good but too small . . . the scarecrow, or a cow would dominate . . . but how about a chicken . . . the right size and color . . it's a Rhode Island Red. It even suggests a title.

All the questions, answers and decisions that result from the planning process, are mine. No one else could or would come up with the same decisions. Thus, the painting has become a reflection of my feelings. While some say planning robs you of spontaneity and adventure, it allows me to be the director, rather than the spectator of my own creation.

"Calvary II", watercolor, 22 x 15" (56 x 38cm)

"The word", watercolor, 22 x 15" (56 x 38cm)

about the artist

"Self Portrait", pencil and acrylic, 14 x 11" (36 x 28cm)

Tom Huntley studied at the Vancouver School of Art in 1946 and completed the first commercial art course presented by the school. He went from there to an apprenticeship with a lithographic artist. This grounding prepared Tom for a successful career in commercial and advertising art. He was Advertising Manager of CKNW Radio and had an 18-year stint as Vice President and Creative Director of Foster, Young, Ross, Anthony. He concluded his commercial career as Marketing Consultant to Woodward's Food Floors.

Since retiring, Tom has been active in the Federation of Canadian Artists, serving on the Board of Directors, and he teaches drawing in their Foundation program.

Tom has also taught many workshops and given painting/technique demonstrations to various communities in British Columbia.

Tom works in a full range of media and is always ready to try something new. His creativeness and keen interest in all aspects of art is always present and has inspired many other artists. His finely honed sense of humor and impish wit often reflect themselves in his paintings, to the delight of those who collect his work. Tom covers a wide variety of subject matter with particular emphasis on portraits, for which he has received many commissions. His work is held in private and corporate collections in Canada and internationally.

brianjohnson

I call it visualization not composition

Can one formula solve every composition problem? How do Right Brain and Left Brain thinking play their part in design? And where do strong ideas come from?

I am sitting in front of the sign in my studio that reads KISS and trying to do the compositional equivalent of cramming six pounds of stuff into a five-pound bag. I have created a great pile of notes on composition for my chapter and can't think of a way to string them all together. Look again at the sign . . . signs bearing these initials were placed all around the aircraft facility that designed the incredibly complex SR-71 Blackbird. KISS stood for KEEP IT SIMPLE STUPID. Meis Van Der Rohe said it more gently with his "LESS IS MORE".

KISS seems to head me in the right direction, but what do I leave out? What is important? It is very much like painting.

It is now nearly Christmas and I am still looking. Wandering around the house I pass the Christmas tree and, eureka, there it is, a graphic example of complexity unified into one visual statement — what, in composition terms, equals unifying all the choices made in dressing this tree? Is there a compositional equivalent that will allow us to unify all our dos and don'ts and successfully string them together?

Let's see how the formula, CHRISTMAS TREE=CLEAR, STRONG IDEA works. Will it solve all the problems of composition? It seems a tall order for five words, but let's see what happens.

The Christmas Tree Concept

A graphic example of complexity unified in one visual statement
CHRISTMAS TREE = CLEAR, STRONG IDEA
CT = CSI

"Netminder", acrylic, 19 x 25" (48 x 63cm)

Let's see if the formula CHRISTMAS TREE=CLEAR, STRONG IDEA (CT=CSI) will work on an early painting.

Thin sunlight on a dark day, the tail end of winter. A boat drifts by with two young boys in it. One has cut the end off his goaltender's hockey stick to make a paddle. This is incredible — Canada's answer to Ground Hog Day — a visual ode to spring.

To simplify, I remove one of the kids from the boat . . . nothing in the water . . . no flotsam or jetsam . . . no reflections. . . no wharves, trees, shoreline or sky.

The water is dark and dead calm. I can see the rings in the water from the drips off the paddle. Now, using our formula (let's call it CT=CSI from now on), let's work our way through the painting.

To get the even deep surface I wanted lots of control, so I picked acrylic. Nothing to distract from the cut-off stick and drips.

The composition now has two elements: the water and the boat. All I have to figure out now is how big to make the boat and where to put it. Instead of a bunch of thumbnails, pencil study, colour study, full-size tracing, and so on, why not just roughly draw the boat and boy at several different sizes, cut them out and move them around until it seems right . . . more about this later.

As for the rest, CT=CSI seems to suggest dark values so that the drips and rings will read I use analogous hues of low intensity to help key the mood. I choose high value contrast for the same reason. These criteria are all determined by the need to keep the focus on the end of the hockey stick, because this is what the story is all about.

The painting was almost composed before I drew the first line.

Design plans

✔ Work with a clear, strong idea.

✔ Try visualizing the composition before you touch the paper.

✔ Use cut-outs to test placement.

✔ Ensure elements have a specific function.

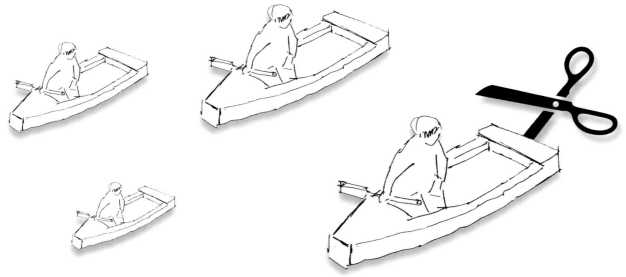

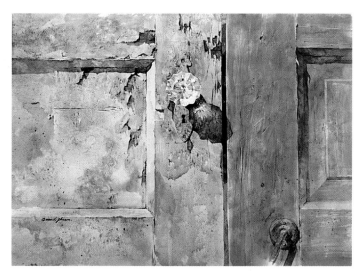

"Pearl", watercolor, 20 x 27" (51 x 69cm)

"Remembrance",
watercolor and gouache, 19 x 25" (48 x 64cm)
The Christmas tree can be an established classical design configuration.

Mondrian spent more than half of his painting career working with it — how to divide a rectangle using only vertical and horizontal lines. At art school we would get this problem assigned in a variety of ways. For example, make five divisional lines and colour in each resulting rectangle using an analogous colour scheme. I find I have to do an elaborate pencil study on these in order to plot the smooth/rough, big/small, neutral/intense, linear/solid, out/in, dark/light, and so on, surfaces that will be adjacent to each other. This is a wonderful opportunity to put six pounds of stuff into the five-pound bag and it's a worry-free format . . .once everything is locked in at the pencil stage, it's clear sailing.

"Fort Rodd Hill Revisited",
watercolor, 20 x 26" (51 x 66cm)
Here's another early painting we can put to the CT=CSI test.

It was an almost raining day. Jean, the kids and I were at a local historical site and the only ones in this part of the fortifications. I had just glanced through a doorway at a display of old uniforms and could hear the children's' voices echoing throughout the underground munitions rooms. As the history of the place settled on me, the sound of the children's running footsteps caused me to wonder about the times these same rooms had come alive with the clatter of boots as the alarms were sounded. At that moment I decided to paint the uniform hanging before me.

These sights and sounds will be the CT=CSI for the painting.

How much of this can be composed before I touch the paper? If I leave the neck of the uniform and make it tangent to the top edge, I may just be able to make the viewer, at first glance, fill in the rest of a soldier's image. Within these dynamics of setting, plus the addition of two first readings, (the helmet and the tangent), I can try to get the viewer to experience that same sense of being-in-two-places-at-once that I experienced when I stood in the present and felt echoes from the past.

There is no floor shown because I want to lose the bottom of the figure, therefore I am going to have to get in close, and that doesn't leave much wall . . . the bedding and paraphernalia have to be arranged to cut off more of the lower portion of "the figure". On checking my original notes I see that it was here I went to a pencil study, and added a window to explain the position of "the figure".

With CT-CSI there is no need to wonder what should go here or there, or if I should add this or that, because the elements of the painting all have a specific function.

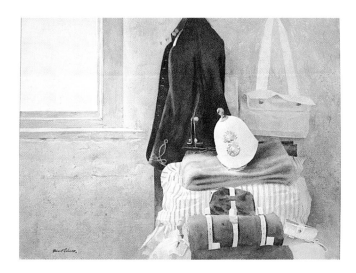

90

now let's try a combination of left brain/right brain thinking

The previous examples have been mostly left brain compositions. Now let us see if the Christmas tree idea holds up in compositions that are more or less half left and half right brain (let's call them LB and RB). So far there has been little room for RB painting. I have eliminated spontaneity and the "happy accident" in favour of graphic clarification of the strong idea. I am going to compose now in a way that lets the RB in, because it will solve even more compositional problems if given the chance. (There's lots of information on Right Brain thinking now for artists).

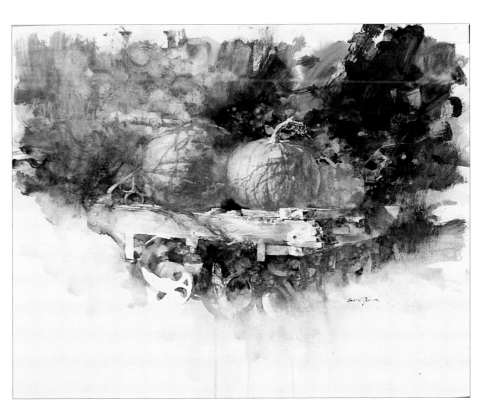

"The Forge", watercolor, 20 x 26" (51 x 66cm)

"Matt, Brad and Karen", watercolor, 20 x 27" (51 x 69cm)

Here are two examples of left brain/right brain thinking.

The more detailed the study (LB) the less chance for the RB, so I am going to have to ignore compositional guidelines — no thumbnail, no pencil studies, and careful drawing only on some areas of the subject so I can preserve my whites.

The subject is placed comfortably near the center, because I don't want to lead myself into a preconceived mood. There is no background suggested, it's sort of a one-person jam session, just go with what you've got, lots of runs,lifts, wipes, scrapes, mixing as I go on the board, whatever feels right. I have some anxious fun with it — lost and found edges, paint as fast as possible, twelve hole muffin tin with watercolours mixed to consistency of poster paint, large butcher tray palette with fresh squeezings on it, lots of brushes, no fiddling at this stage, slowing down now as I paint into the subject areas, but I want it all bashed in this one session. This is a messy procedure and so I need the strongest of subjects. I can clean up the watercolor with gouache, electric eraser, sandpaper, scrubbing, repainting in the following LB sessions. It is during these that I will very carefully do my fiddling until things look right.

composition and complex subjects

"The Retreat",
watercolor, 19½ x 25½" (49 x 65cm)

As with the previous two examples, I can't isolate composition from the procedure or the medium. These subjects are too complex for me to paint all at once. Either the subject or the surrounding areas will suffer as I try to bounce back and forth between LB and RB. In both cases I put a careful drawing down and painted it with no idea of the background.

"The Old Folks",
watercolor, 14 x 17½" (36 x 44cm)

I had all the apples in and most of the basket before I touch the background; it was merely a comfortable amount of space left around the basket.

CT=CSI was the basket — it had been my folks' and was used to gather windfalls in their back garden. Painting with the basket in front of me left no confusion about the surrounding areas; I wanted to reflect my memories, to leave people with a warm feeling. The background could have had suggestions of flower cuttings, clippings, whatever. At this point it depended on what I had for breakfast that day as much as anything else. Again, I made no pencil study. I am composing with the RB as I go, using the painter's equivalent for the words: bright, happy, cheery, kind, considerate, and so on. It's a portrait.

right brain thinking allows watercolor to shine

The right brain is where watercolor shines — it's the perfect medium for RB painting — lots of paint, big brushes and go to it! At this point, medium, composition and CT=CSI become inseparable. The subject emerges on its own, just as the ancient Chinese painters did it. It's interesting that these paintings show little evidence of the painter — there doesn't seem to be much sign of brushwork — that's the RB at its best.

I should note here that RB could also result in a real mess, because only about one-in-five work out. This is a high attrition rate, but it is well worth the effort.

The only thinking before I start is "ocean" or "land".

right brain only compositions

Finally, does the CT-CSI hold up with right brain only compositions?

The only people I have ever seen paint successfully, consistently, with great authority, unselfconsciously and without fear of failing were about four years old. These pre-schoolers had easels with five or six waist-high paint pots that sat in holes along the easel front. Each container was filled with the colors of the day and had its own brush, a perfect set up (my muffin tin idea started here) to just let 'er rip.

I have always set aside time from my painting schedule to do this very same thing — get out a bunch of boards and just "have at it" (no thought of subject). I remember that one of the kids' chores was to burn these early piles of experiments in the incinerator.

How does all this relate to composition? Well, one day these experiments started to appear, Phoenix-like from the ashes, as paintings with the look of places we had hiked through. This was exciting stuff! Right about then I met a scholar from the Beijing Art Institute; he was interested in the work and I told him (through an interpreter) about my new and exciting discovery. He then told me with great diplomacy and embarrassment that this had been known five thousand years ago in China and he went on to explain that the painter could go to a location, and for as long as it took, as we might say, "soak it up", and then write a poem about it, no paintings, no drawing, just the poem. They would then leave and sometime later this internalized image would appear as a painting. This caused me to remember something I had read years ago about Ingres, who directed the French Academy in Rome in the 1800s. Ingres said of his paintings, that he was most pleased with the ones he didn't know he knew how to do. All this sounds familiar in the light of what we now know about right brain painting.

**"Breakwater",
watercolor, 15½ x 21" (39 x 53cm)**
This partial vignette is just as it emerged. I did not fiddle with it except to add the gulls, because they are always up in our storms.

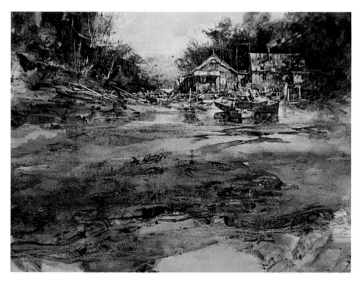

"Dollarton Flats", watercolor, 16¾ x 21¾" (43 x 55cm)
Here is an example of one of these "emergences" that I felt like revisiting through the addition of two-dimensional carpentry — a shack here, a boat there.

I had spent many enjoyable hours at this place sketching, painting and talking to the old folks that had built these boats and shacks. I would set up a mini-studio there for the day: chair, umbrella, table, and so on, and paint away. Like the Chinese painters I had spent many hours soaking all this up.

"Camel and DR.1",
watercolor, 20 x 25" (51 x 64cm)
In this case the strong idea started in Grade 4 when my teacher
would remind me that scribblers were for doing schoolwork, not
drawing Spitfires. A life-long interest in aircraft allowed an easy
transition to CT=CSI. I had done years of research and was darned
if I was going to waste it all by having a complicated background
that would detract from the hard to acquire detail of the aircraft.
The sky's only function was to hold the planes in space and serve
as a background to paint against.

where do strong ideas come from?

The remaining question is where do strong ideas come from
that will start us off and see us through to the end of the
painting?

I try not to think of composition so much as a means of
arranging shapes, but as the process of putting myself in
front of ideas or pre-existing compositions.

For example, when I've headed out in the dark of a
winter morning to wait for the sunrise at the Uplands
meadow, I start the composition by moving through the
snow and puddles and saying to myself, okay, the sun is
going to come up over there, silhouette the bare oaks and
light some of these dark puddles up against the snow. If I
am lucky there are going to be some clouds and the sky will
turn orange and so will some of the puddles.

With this preparation I don't have to try and beat God at
His own game, I can just try to paint what's in front of me
with a minimum of editing and a maximum of humility.

The strong idea may come as something seen around the
house: the teddy bear drying on the clothesline, carved
pumpkins on the compost pile, Jean's elephant collection,
favorite things — and on and on into the night.

about the artist
Brian R. Johnson graduated with distinction from the Art Center in Los Angeles.
He is a member of the Royal Institute of Painters in Watercolours (London).
He and his wife, Jean, live in Victoria, BC, Canada.

just placing it there, revisited. an exercise

I mentioned earlier that I would discuss this business
of "just placing it there" without thumbnails.

For a long time I have suspected that painters have
developed a sense of where things go, but for some
reason often foul up. Acting on an invitation to conduct
a watercolor workshop, I decided we could explore this
phenomenon as part of the program.

I brought illustration boards, lots of paint, and
cropping ells, and told the students about the pre-school
kids and my experiments. The guidelines were to just go
at it, with no subject matter; just concentrating on shape,
pattern, texture, thick and thin paint, line, mass, pours,
washes and whatever groups of opposing elements they
could think of, for example, dark/light, neutral/intense
and on and on. The next procedure, using
the cropping ells, was to find in all this
some non-subjective paintings. Without fail
everyone discovered gem-like little works
by instinctively cropping in. A lot of these
miniature paintings were no larger than two
inches by three inches, but they were far more powerful
than what is normally achieved by standard left brain
approaches.

We seem to be far better at composing "after the fact"
and we automatically reduce the number of elements —
"less is more".

I think the above exercise is the quickest and surest
way to learn to compose well. I suggest saving exercises
like these and considering which ones best describe
words or moods. Think of words like calm, lonely, swift,
fog, strength, cold, and so on. Through this type of
practice we learn to recognize a feeling of rightness . . .
"just put it here".

VISUALIZE INSTEAD OF COMPOSE
We could also consider replacing the word composition,
because it doesn't clearly define what we do at the
initial stages of a painting. The word verbalize seems to
adequately describe the concept of converting thought
or emotion into words, but we need a word that defines
converting these same thoughts or emotions into graphic
shapes. The word visualize seems more like the painter's
word and may lead us more directly to the image. I hold
the established procedures in high regard and use them
frequently, but feel that often they can serve as a
roadblock to any right brain thinking.

I am still not sure where composition/visualization
stops and starts in all of this, but I hope my formula
defines some of its vague borders. Good luck.

neilpatterson

try my "before and after, but never during" approach to design

For many people, composition and design are the essence of painting. I tend to approach my work in a different manner. I believe that if I know what the paint will do, and how it can be manipulated on the canvas, then design and composition problems can be corrected at any time.

I approach design in the simplest way possible.

I start by dividing the canvas into three equal sections top to bottom and side to side. The points where the lines intersect become possible places for the center of interest.

BE PRECISE — BUT NOT AT THE BEGINNING

After choosing one of these points as the center of interest I immediately begin to paint. I do this with good reason. For me, dwelling on the design of a painting at this early stage is counter-productive. I believe a painting should be spontaneous and full of feeling. I think that calculating every move results in a stiff, uninspiring representation.

I was trained as an architectural draftsman and all work had to be very precise to within one-sixteenth-of-an-inch. This type of training was not ideal for people like me, who paint in a very loose style. However, there

is nothing wrong with precision — quite the contrary. Even though my paintings are loose, one-sixteenth-of-an-inch can make all the difference in the world to a result. It is important to realize that even in a loose painting one must be precise. The difference is, I don't try to be precise at the beginning of a painting — only at the finishing stage.

THERE HAS TO BE SOMETHING IN THE CENTER

There is a rule stating that nothing of interest should be in the center of the painting. But, if I followed this rule religiously there would be huge spots of "sweet nothings" in the middle of all my canvases. Something has to go there — I'm sure I would not sell a painting with the center unpainted. What do I put there? Have you ever tried to put a building in the center of a painting? It can and will work! To make it work, you must find a means of drawing the eye away from the center.

So you see there are "rules" that can be broken. I break this rule all the time.

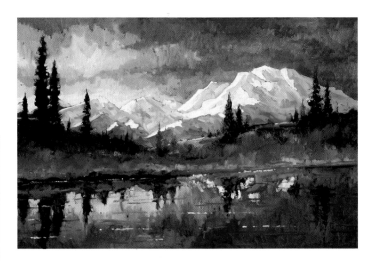

"Alpine Lake", 24 x 36" (61 x 91cm)

what about the horizon line?

Often, I will make the horizon line just slightly off parallel with the canvas. The same technique applies to trees, buildings, and fences — if they create a line on the canvas I always paint them so they are not

Design plans

✔ Avoid "sweet nothings" in the center of your paintings.

✔ Avoid static shapes. Substitute dynamic ones instead.

✔ Think about painting the horizon line just slightly off parallel.

✔ Think how you can lead the eye.

✔ Use your brush as a composition tool.

A big hole in the center?

The rule says — don't put the focal point in the center of the painting. But if you do that, you will end up with "sweet nothings".

Solved

Here's something in the center. I made this painting work by carefully not drawing attention to the center. Note the zig-zag path leading to the figure and the path that goes past the building, not up to it. This painting is called "Going Home".

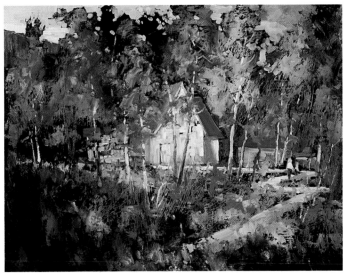

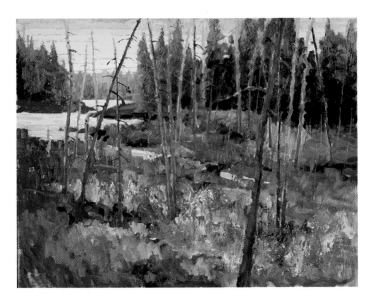

"Golden Sky", 24 x 30" (61 x 76cm)

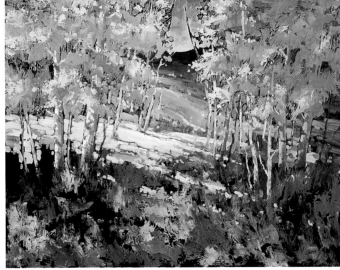

"Aspen Light", 24 x 30" (61 x 76cm)

parallel with the canvas. Trees are also more interesting if they are not too straight. Even if the tree is straight in reality it will look better in a painting if it is a little crooked.

how shapes work in a painting

Let's see how shapes relate to this painting. Here we see a triangle on the right. In order to stop the eye from going off the canvas I put a tree at the end of the triangle. The tree serves to catch the eye and stop this from happening. Of course a rock or other object would work equally well.

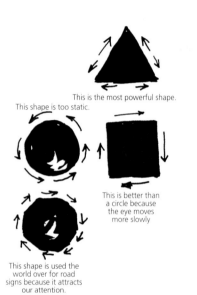

This is the most powerful shape. This shape is too static.

This is better than a circle because the eye moves more slowly

This shape is used the world over for road signs because it attracts our attention.

**Still life,
24 x 30" (61 x 76cm)
Squaring off
round corners**
I've broken up all those round shapes.

Square off the round corners

Let's look at a still life example. Because an orange is round, it is a static shape. When I paint an object that is round I will square off the corners and this makes it much more interesting. This technique will also apply to any other object with a rounded shape, such as vases, bottles, and teapots.

"Black Bear", 24 x 30" (61 x 76cm)

your brush can be a composition tool as well

Brushwork is also an important part of design and composition especially when you are painting with oils. A smooth paint surface will reflect light and a rough surface will absorb light. The smooth surface will also attract the eye, because it reflects more light. Shiny surfaces attract more attention than dull ones. Thicker paint will attract the eye more than thin paint, because the thick layer of paint appears closer to the observer.

SHAPES CAN CAUSE PROBLEMS IF YOU ARE NOT CAREFUL

There are many different shapes to look for in a painting including circles, triangles, and squares. These different shapes can cause problems. I don't pay much attention to shapes initially. It is only after the painting is almost finished that I begin to look for problem shapes.

What is the most static shape we know? Just think for a moment, look at the world around you and see if you can find the most boring shape.

A circle is the most static shape. When I look at a circle my eye goes around and around continuously. There is nothing of interest to catch the eye and hold it there. Now look for the most powerful shape around you, something that will catch and direct your eye.

Of course it is the triangle, or arrow. Our society is directed by this shape the world over. A good example is the road sign for "yield". It is a triangle with rounded points or corners. The yield sign is not as powerful as a true triangle, because of its rounded corners. Nevertheless it serves to catch and focus the eye to a much greater degree than the circle.

Now what about a square?

A square is more dynamic than a circle. The eye will

continued on page 102

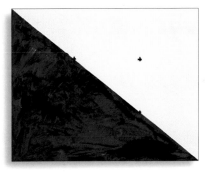

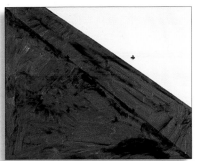

the one-third/two-thirds method

One of the most important aspects of design, is what I call the one-third/two-thirds method. Make one-third of the painting dark, two-thirds light, or one-third light and two-thirds dark. Canvases with these proportions will create a more exciting painting. A painting that is half dark and half light is much less interesting. That applies to equals of anything — color, shape, or value.

how to lead the eye through the composition

Another consideration is how to lead the eye through the painting. Because westerners read from left to right, I tend to bring the eye into the painting from the left side. This gives the eye the same approach as when reading a book or newspaper. The eye is not as comfortable coming into the painting from the bottom or the top. Because of this phenomenon I most often bring the light in from the left side of the painting rather than the right.

**"Sunset Lake",
24 x 36"
(61 x 91cm)**

**"Aspens &
Fireweed",
36 x 48"
(91 x 122cm)**

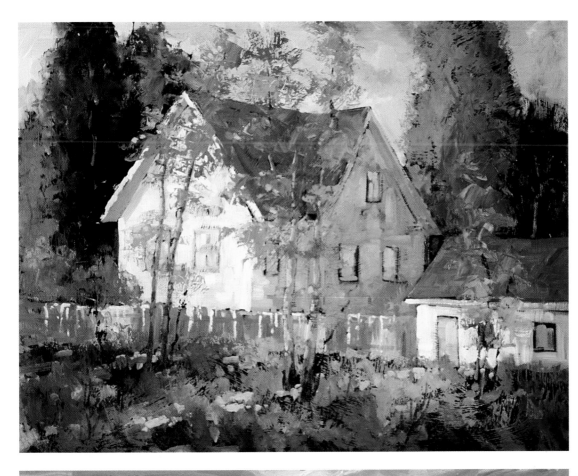

"Morning Light",
24 x 30"
(61 x 76cm)

Test design with paper cut-outs

Nowadays, the canvas will tell me what it needs. It will tell me what color to use and where to to put it. If I am in doubt where to put an object I will draw the object. I will paint it on a piece of paper of matching color and value and then cut it out. By moving the colored paper around the canvas I can see where the object will look the best. More than one cutout can be used if needed.

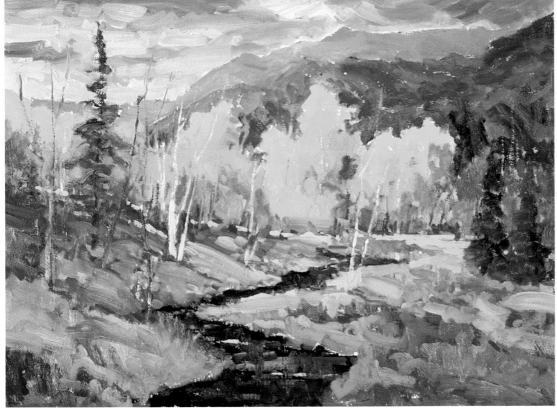

"Bragg Creek",
Alberta, 18 x 24"
(46 x 61cm)

value and color in composition

Now let's look at value and color as they relate to composition and design. Some people think color has no business in the discussion of design. I disagree. Color is an important part of design. For instance, I always make sure colors are close in value to each other around the edges of a painting. Trees going off the canvas should be closer in value to the sky next to them. Care must be taken so the trees are not too dark or too light in value. If the tree is too light on a dark sky, or too dark on a light sky, the eye will be led off the canvas. For the same reason, when you place things like a log, a lake, or even a hill at the side of the canvas they must be close in value to the adjacent colors.

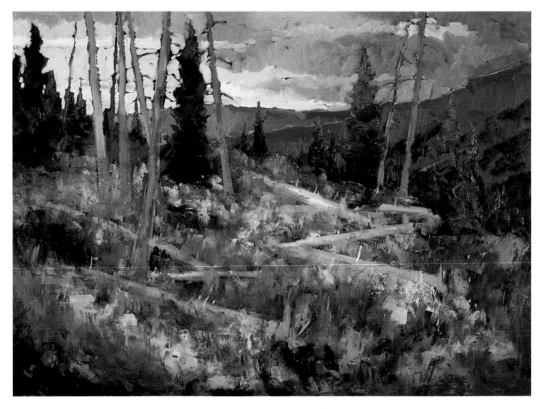

"High Country Colors", 36 x 48" (91 x 122cm)

good design avoids straight lines

Avoid straight lines because they are static and uninteresting. For instance, I find that the roofline on a house looks better if the lines are not perfectly straight. Even though the line of a building is straight and true in reality, to draw it this way in a painting is boring. This is a concept I learned after spending years in the field of architectural drafting. When I first began painting, I would end up with a nice loose painting and a building that was so perfect and straight that it looked out of place. I discovered that lines not drawn perfectly straight were full of movement and feeling.

continued from page 99

move along the line to the first corner when the right angle interrupts it, giving the mind something to think about. The eye moves more slowly around the square because of its corners. It is much more interesting because the eye must change direction.

THE MORE YOU PAINT — THE MORE THE COMPOSITION LOOKS AFTER ITSELF

My last word of advice to you is to think about design before and after painting, but not while you are painting. Plan the basic design first, allow the painting to flow intuitively and then assess the painting when it is finished.

The more I paint, the more composition and design look after themselves. In the early years I admit my design was limited. However, over the years I have intuitively learned more and more about it. I think every artist has their own unique sense of design, just as they have their own unique sense of color.

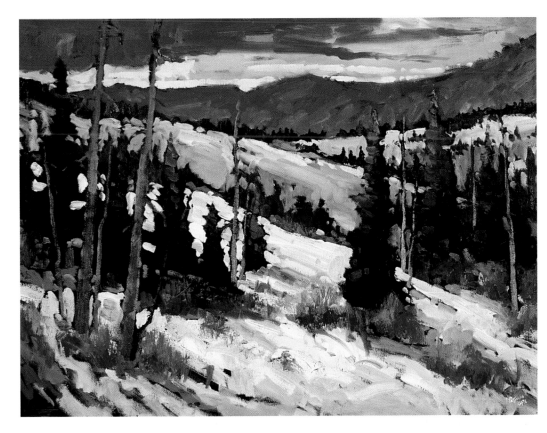

"Chinook Cloud", 30 x 40" (76 x 102cm)

"It's like going back to childhood. You forget about rules and just put colors next to one another."

about the artist

Neil Patterson is an internationally acclaimed artist and workshop instructor. He studied at the University of Calgary and the Scottsdale Artists' School. He is a member of the prestigious Salmagundi Club, New York, NY; a signature member of the Alberta Society of Artists; Federation of Canadian Artists and he was the first Canadian to be awarded master signature membership in the Oil Painters of America.

In 1995 through to 1999 he achieved a place in the "Top 100" and "Top 200" in the US "Arts for the Parks" competitions. Neil's flower paintings were reproduced in "The Best of Flower Painting" (North Light Books). In May 1999 he took part in the Carmel Art Festival Plein Air Competition held at the Pitzer Gallery in Carmel. Collections holding Neil's work are too extensive to list. His work has also been featured in *International Artist* magazine.

myfanwy**pavelic**

I use my intuition

I never consciously think about design and composition. I just know what looks right.

Before I start a painting of a person, I focus on the subject and pick out a particular shaped canvas or board according to how much of the subject I want to include. I often use an old canvas and I particularly enjoy painting over something I've already done, allowing bits to come jumping through accidentally. Many "starts", and even finished drawings and paintings, may be done before I decide how to proceed. The composition happens as the work progresses. Often the messy background makes it easy to disperse shapes as needed. I'd rather it took over me than I took over it. And that probably expresses how instinctive, how intuitive, my painting is.

I've never been content to churn out "bread and butter" paintings. When I became tired of oil painting at one stage, I used collage and this proved to be influential in the design and composition of my later works.

Design plan
An extraordinary portrait

These stages show the progression of the painting of the late Rt. Hon. Pierre Elliot Trudeau. Tape and paper were used to mask the areas where the background was to meld with cape. Many drawings, paintings and sketches were done before I started on the major painting, so that I could find the pose and mood that I felt best portrayed the man.

A canvas literally covered in yesterday's paint and smears of primary colors.

Form emerging.

**(Left) "Self, studio 1989",
acrylic on canvas**
The interesting light caught my eye as I saw myself in the studio mirror. I did this painting for my husband's birthday. There were no problems, it just happened. I enjoyed it because I love to paint hands. It would not have been so enjoyable if the face had not been turned away. On the easel behind me there are three other self-portraits.

"Lazlo Gati, The Conductor"
This is a large piece that happened instinctively. The grey strip on the left was quality artist's paper. The background was brown wrapping paper and was straight at each end because it would look wrong as a simple curve. The pose was Lazli's own, and sheet music was Xeroxed as for the Di Castri image on page 109. I was delighted to find that the eye highlights could be white notes. All the light areas were tissue — including the skin color, which came from sports shoe wrapping. The clothing is entirely Xeroxed music.

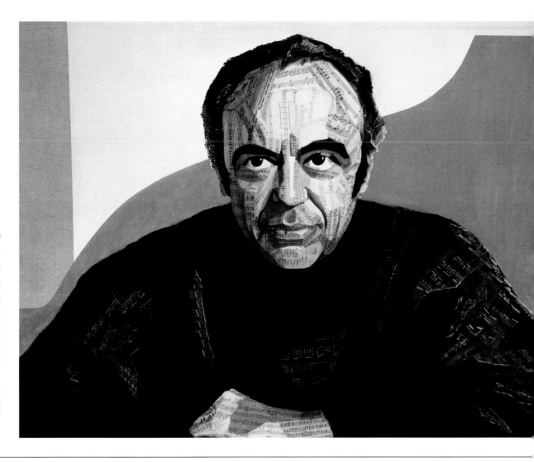

The portrait emerging from an incoherent jumble of color.

Some of the original color may remain as part of the overall composition.

My hand just seems to "do it" without my guidance.

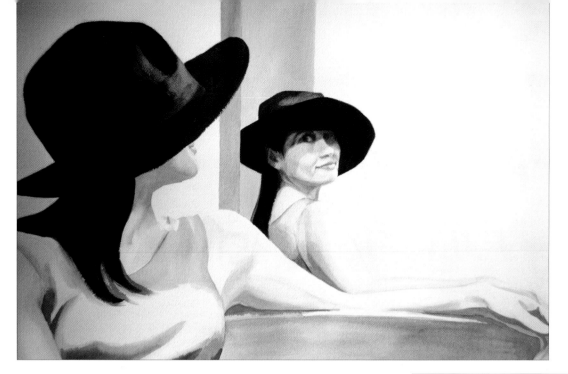

"Angela's Hat"
This was done at a Limner's meeting and is one of a series — one hat on various members. I was fascinated to see that no one wore it in the same way. This work was constructed from paint and collage.

"Surgeon's Hands", charcoal on paper
This was commissioned by a woman who wanted to present it to the surgeon who had successfully operated on her "inoperable" tumor. She left the painting entirely to me. I asked a surgeon friend to show me how he would use his hands while operating.

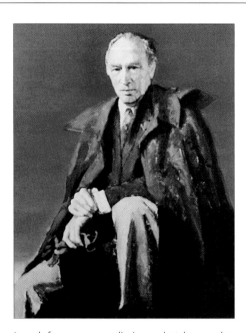

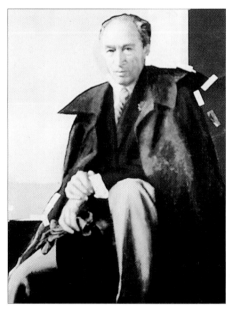

I work from many preliminary sketches — the portraits are never posed.

Masking in place.

"Official portrait of the Prime Minister of Canada, the Rt. Hon. Pierre Elliott Trudeau", 1991, acrylic on linen canvas, 48 x 36" (122 x 91cm)
This painting now hangs in the Houses of Parliament, Ottawa.

"Katharine Hepburn", acrylic on canvas
Katharine felt that this painting had captured her. I had done many paintings and drawings of Kate, nearly always in front of a roaring fire, even in the middle of summer. She is a very vocal, positive person, very amusing and lots of fun to be with. This painting will eventually be hung in the National Gallery, Washington DC.

"Kate Laughing", charcoal
This drawing was done from a video during an interview and from personal knowledge. It captures her wonderful sense of fun.

(Below left) "Stripes", acrylic on canvas
This is my cousin, JD, sunning himself in California. I sketched him on the spot and would like to have painted it then and there but, although he is also an artist, his paints were in such a condition that nothing could be found. Consequently this was painted at home. The stripes are the shadows from the lattice on his deck.

Turning Point

A momentous thing happened when I tried to draw my 78 year old grandmother. I realized that one eye was exactly right, but try as I might, I could not resolve the rest of the face. I finally slashed paint across it in a fit of despair. Then I saw that the likeness was actually possible if I could use bits retrieved from the mess I had created. I resolved never to paint on blank canvas or paper again.

"Head 68"

I particularly enjoyed this process, which was done entirely with tissue paper because colors were not readily available at the time. I discovered that dress pattern paper was exactly the right color. Some colors were achieved by layering until the shade I needed appeared. On one occasion I found the exact shade I wanted for skin color in a shoe store — tissue paper wrapped around sports shoes. We decided my daughter should have the shoes, in the right size, just so I could get my hands on the tissue paper!

The negative shapes behind the head are black construction paper. The area on the right behind the head was not black because I just knew it wouldn't look right.

There is a straight line through from the neck to the black edge above, similarly there is a diagonal from the shoulder to the right side black edge. Again, this is instinctive composition and design. The original is very obviously thick where the tissue was built up to achieve the right color. It was done very quickly.

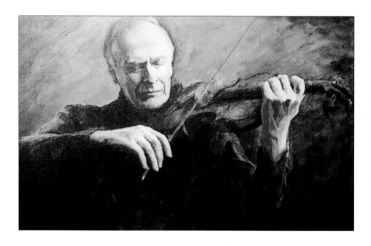

"Forms emerge from canvases literally covered in yesterday's paint and smears of primary colors."

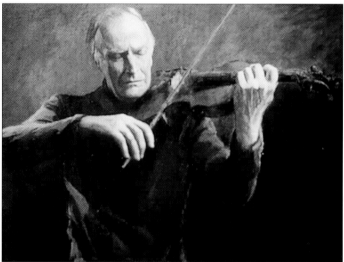

"Yehudi Menuhin", acrylics on canvas

The National Portrait Gallery, in London, told Yehudi that they would like a portrait of him. Various artists were suggested. Yehudi was adamant that he would only sit for a portrait by me. He was willing to travel to my home in Western Canada for this. I did many drawings, paintings and sketches before painting these two. Yehudi was very pleased with the hands and said he would know exactly the sound he was making, by looking at the fingers.

The National Gallery chose the red one but I preferred the blue one.

"John di Castri — Architect"

Architectural papers that he supplied, were torn and cut with sharp scissors. To get the dark colors I asked Xerox if they could produce negatives of the sheets of architectural motifs, and asked for the darkness to vary so that I had a range of grays. It so happened that the lightest area on the forehead and nose had rows of toilet seats and pedestals faintly imprinted on it. The tie was made from found scraps of tissue paper.

about the artist

Myfanwy Pavelic has received many awards including the Order of Canada, Membership of the Royal Canadian Academy and an Honorary Doctorate of Fine Arts from the University of Victoria, where the main collection of her work is now held.

Myfanwy is one of Canada's foremost painters and her portraits grace several important collections. One sitter remarked that she had revealed to the world what he had spent a lifetime trying to hide. Her penetrating painting of Pierre Trudeau, hanging behind his bier, was a truly remarkable tribute to her ability to capture more than just a likeness.

Myfanwy was born with painful, dislocating kneecaps, her schooling was intermittent and she was left to her own devices for much of the time. Her dream was to be a concert pianist and she spent much of her time at the piano. Her talent was obvious. She became extremely proficient, and did play professionally, but was bitterly disappointed when it was realized that her wrists were too weak for a career as a concert pianist. Drawing was never as satisfying to Myfanwy as music. She said that even a really good drawing did not please her as much as playing Mozart really well.

When Myfanwy was 11 she listened to Yehudi Menuhin's very first concert at Carnegie Hall, in New York, and was struck by his talent and dedication. Later they were to become very good friends. Her magnificent portrait of him hangs in the National Portrait Gallery in London. Over the years she painted and drew him many times.

Myfanwy enrolled in a particular class at the Students Art League in New York because she was interested in a professor whose work was so different, and she thought she would learn something new. There were about 50 students and "it was hard to see what was being sought after". Eventually the professor came to her and after talking to him she realized that she was not going to further her career, so she resigned at the end of the first day.

At the age of 18 she was encouraged to show her work to the prestigious American Portrait Academy. At the time she did not realize the significance of this. Her very first commission was "a dear little woman like a teddy bear with black eyes and white hair". She had a long string of pearls which were very important to her and were counted after each sitting. This lady was delighted with her portrait, and as soon as Myfanwy had finished she presented the astonished artist with a check for $1000. This was immediately spent on a gramophone, two records, and a taxi back to her room.

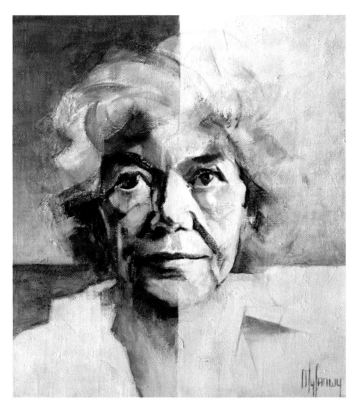

"Head 67"

This was a self-portrait because I was the only person around at the time. My enjoyment of collage is evident. I used the cruciform background shape because the horizontal line was in line with the mouth and the vertical lines up with center of the forehead, nose and neck. This was completely instinctive design and composition.

nancyslaght

I choreograph movement into my still lifes

When my painting is at its best it should appear a little edgy, as if it's going to tip over. Paradox, metaphor, ambiguity, irony — this is the stuff for which I strive.

Blaise Pascal said, "all the unhappiness of men arises from one single fact, that they cannot stay quietly in their own chamber". Perhaps it is this need to be still that draws me to my art. It is ironic that the subjects of my work are still life, while my personal experience has been one of adventure and even recklessness. To suggest that the process of painting is cathartic might seem like a cliché, but for me it works.

SEEING SOMETHING NEW

When I allow the sting of personal experience to prick the ennui of old habits and lazy perceptions, there is always a chance that I'll see something that I've never seen before. And if I'm really lucky, and reasonably disciplined, once in a while I'll pry a nugget from my deep and secret place and share my discovery as a pastel painting.

I am reminded of this dynamic when I sail my 27 foot sloop around Vancouver Island. Attentive to the wind that heels the boat over until the ocean threatens to flood the cockpit, I am aware of unseen forces below the water that press against the keel, countering the effect of the wind and contributing to the boat's self-righting

ability. With skill and faith, I balance and direct these forces using the rudder, squeezing my boat in the correct direction like a wet pip pinched between my fingers. When my painting is at its best it should also appear a little edgy, as if it's going to tip over. Paradox, metaphor, ambiguity, irony — this is the stuff for which I strive.

As you can see, I fit rather comfortably into the west coast stereotype. And I am unabashed about my enthusiasm for all those curious people on the Gulf Islands who paint their bodies and sell vegetables to tourists at the Saturday morning farmers markets. However, I am not satisfied to be an entertaining remnant of the 60s. I allow this rich culture I live in, and the experience of my largely misspent youth, to create an opportunity to make an honest woman out of me.

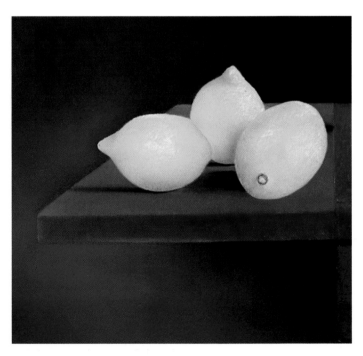

"Lemons" (See the left one of this diptych on page 113), 12 x 12" (31 x 31cm) each

Design plans

✔ Ask why the subject is being painted.

✔ Decide where the lines, shapes, forms and color should be positioned to convey the intention.

✔ Create tension with dynamic placement.

✔ Use contrasting color.

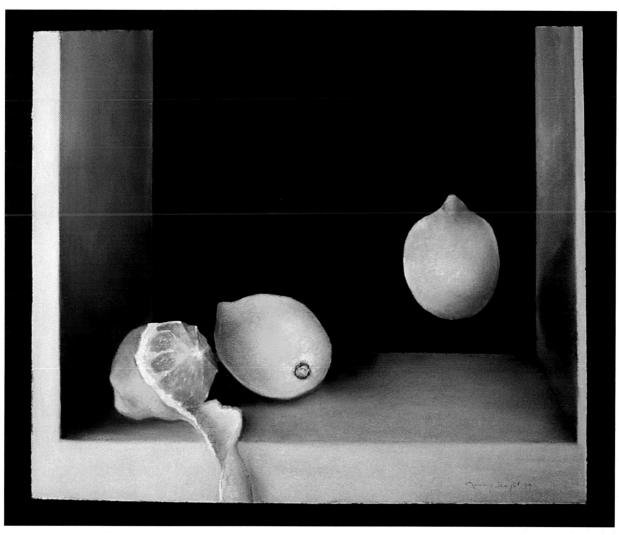

"Probabilities", 11 x 13" (28 x 33cm)

Viewfinding efforts for "Lemons"

Sketches for "Lemons"

"Parade", 12 x 19½" (31 x 49cm)
This was my initial composition inspired by the idea of a line up of fruit.

"Dominoes", 13 x 13" (33 x 33cm)
At a later date, still interested in the concept of a line, I reduced my palette, changed perspective and arrived at a strong composition. It was my "keeper"!

"Earthenware", 13 x 13" (33 x 33cm)

What the hell; if my paintings sell it must have all been worthwhile, right?

MAKING DECISIONS AND LIVING WITH THE CONSEQUENCES

Just as I've conducted my life, I compose my paintings. I make decisions and live with the consequences. I assume knowledge of how to draw and paint and choose my subjects spontaneously.

Two questions arise, why am I painting this subject, and where will I position my lines, shapes, form and color in order to convey my intention? For me, this defines composition, because it provides the foundation, the structure necessary for my subject to take form.

By establishing a dynamic sense of composition I hope to avoid the common pitfall of substituting clever (even cute) technique and beautiful color in place of substance. I consider composition the stimulus essential for integrity. It facilitates exploration, while maintaining focus. Not all attempts are keepers!

As I work with various objects I arrange and rearrange them into miniature sets, using a viewfinder to determine positioning. I may sketch several variations before I'm satisfied. Sometimes it can take as long to compose a painting as it does to execute it. If I'm impatient with composition, and Lord knows I am, then I will either become blocked or fall into the pitfall of compromise, hoping to "get lucky". This seems to work for some artists, but not for me. My natural angst must always be harnessed to my original inspiration.

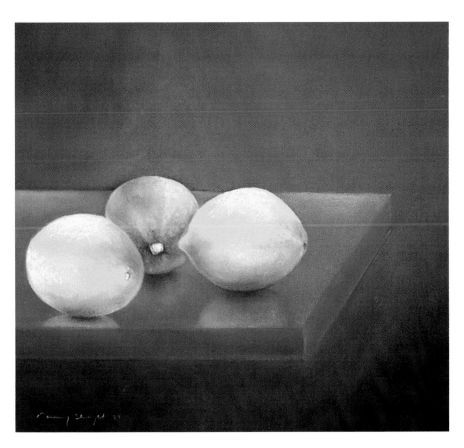

Viewfinding efforts

"Limes" (diptych with "Lemons")

THE IDEA THAT SPARKED A SERIES

Recently, while browsing through the produce department of a grocery store, as is my habit, fondling produce, speculating on their curious conformations and investigating their secrets, I was drawn to the shapes and hues of an assortment of peppers. Their curious colors and crevices seemed to make an interesting comment both individually and collectively. Also, I found myself personifying their relationships with one another and speculating on an artistic possibility. Some people are compelled to spend money on expensive jewelry while others indulge in their attire, in my case, give me an afternoon in the produce section. I bought the peppers, of course!

Filled with depraved enthusiasm I rushed home with my treasure, forgetting my original mission, to purchase groceries that actually sustain life. Confirming the notions my friends hold regarding my eccentric lifestyle, I began hammering nails into the wall, suspending my vegetables on strings. They spun, twisted and fell. I tied and re-tied them, changing their positions and proximity to one another until satisfied that I had achieved the movement that I was looking for. My experience as a dancer helped me to consider rhythm as I choreographed the peppers in various positions and patterns. I wanted the peppers to communicate with each other and the viewer. I was delighted! Some compositions became whimsical, even humorous, others sensual, sometimes pensive and perhaps even odd or mysterious. One painting tumbled and danced out of the other. Over time, the peppers began to spoil,

"Two Birds in a Box", 19 x 21" (48 x 53cm)

"Hanging Series #9", 11½ x 19" (29 x 48cm)

"Hanging Series #10" (diptych), 4½ x 10½"
(11 x 26cm) each

dry and even shrivel. I refrigerated them overnight then started over again the next morning.

BOUNDARY ISSUES

At a recent art show, I was gratified when people looking at my paintings commented that my work provoked them to consider boundaries, communication, solitude and intimacy. One woman mentioned that they evoked thoughts of family. A gentleman referred to the tenuousness of our lives, and another said she was watching a dance of life. This is interesting considering that they had given expression to my unstated and unwritten intention. I hadn't spelled this out in either an artist's statement or the titles. Ironically, dancing

and choreography have always played a central part of my life. To see this interest channelled into my art was deeply fulfilling, confirming my belief that still life need not be still, even as I am always restless.

It seems that my viewers were nudged not only to ask questions but also wonder. Some even offered perceptions that I had not consciously intended. While there are artists who are troubled by these comments, I find them intriguing, very much appreciating this sort of feedback, and am flattered by the viewer's involvement. There is always a lot more going on in any situation than that which meets the eye. As with sailing, we notice the billowed sails shaped by the wind, but a basic appreciation of physics is needed to realize the

"Fear Series #2 Aging", 6 x 20½" (15 x 52cm)

"Hanging By a Thread", 13 x 16" (33 x 41cm)
This painting was a variation in the Hanging Series that began with peppers and continues to inspire new compositions.

about the artist

Nancy Slaght didn't get down to the business of making art until somewhat later than average, at 40. She'd been busy feeding her need to experience life by marrying too young, traveling in a rock band and living all across Canada, as well as in Great Britain, Europe and Japan. She was a gypsy, at home on land or sea. Having tried a number of different careers, sales management, fitness and teaching, she finally enrolled in the Victoria College of Art. She believed that the west coast, which seemed a place where abnormal people appeared normal, might become her ideal home.

After two years, Nancy was ready to snap her brushes, burn her canvases and withdraw her tuition for the following year. But then she opened a cheap box of chalk pastels. Their alluring ability to function as both drawing and painting medium hooked her completely, and she set her sights on becoming a professional artist.

Her family of pragmatists, professionals, engineers and teachers, made comments like, "art-making is a great hobby, but don't try to make your living at it". These remarks were just enough provocation for her to follow the prompting of another voice saying, "Go for it!". But she does credit her parents with giving her a broad-based view of life, and providing a healthy balance to her esoteric nature, both of which have contributed to her success in making a perfectly practical living with her hands.

In addition to creating her gallery work, Nancy is now back at Victoria College of Art, this time as a teacher of pastel drawing and painting. She's represented by Winchester Galleries in Victoria and the Quest-Avens Gallery in Canmore, Alberta.

importance of the unseen, the rudder and keel below the surface.

Still life isn't still. There's a dynamic amid the mundane that can be so much fun.

Composition is my delight, my pain, my longing, my humor, my temptation and fear expressed. When it works well, it reaches beyond myself to the viewer who relates personally, who finds their own metaphor.

DARE TO SEE

When I teach I often wish I could wave a magic wand. There are many students technically more capable than me, but so often they rely only on the objective eye. During a 10-week session one student, with lots of technical ability, "lit into" me for failing to demonstrate enough technique. How was she to learn to paint sky or water? While I agreed that she needed to know how to make marks and lay down color, I suggested the eye of the architect is important but as a mature artist one must look further. She wasn't persuaded. Funny thing though, she not only finished the course but enrolled for a second session, after which she thanked me for the experience. She opened her

"Three Shells", 15 x 22" (38 x 56cm)

own eyes and dared to see what wasn't there.

This is my wish for all of us, that we find a view of life that is not always obvious. If I have the courage to be vulnerable, the discipline to persist and the modesty to keep learning, perhaps I will earn enough respect to keep contributing to this process and eventually follow my vocation to Saltspring Island where I can join other 50 year-old hippies, paint my face and fondle the vegetables at the Farmers Market. As for Pascal, well, nobody is perfect.

I design for a strong emotional response

A painting with a message does not happen by accident. It happens when you place elements in their order of importance. This means you have to understand how the human eye behaves when it views a scene for the first time. Work with that knowledge, and your paintings will have more drama and will evoke strong reactions.

When we look at a painting, listen to a piece of music, read a novel, or watch a movie we are taking in the artist's composition. The composition is the totality of the work. It is the order in which the artist places the elements to make up the whole. Music is made up of notes, novels of words, paintings of colored shapes. All these basic elements come together to prompt an emotional response in the viewer or listener. The art is in composing the elements to evoke the intended emotional response.

5 THINGS TO CONSIDER

1. Because we are visual artists we first need to understand the visual elements that make up our normal way of seeing.
2. Then we need to have some sense of how these visual elements are picked up and perceived by the observer.
3. In addition to this understanding, we require consummate control of the tools and mediums of our art form.
4. Familiarity with the various techniques of the craft are paramount.

Design plans

✔ Ask why? where? what?

✔ Create points of interest using contrast.

✔ Organise the order of importance to lead the eye.

✔ Decide on a theme.

✔ Use shape, value, and color to create harmony.

✔ Use edges/transitions.

✔ Include signs of life.

5. Finally, an artist must have something to say or communicate which draws on all this previously learned knowledge.

Composition is merely deciding where the elements should be placed in a work, and how they should be treated to get the desired response. We need to solve questions such as:

Where should that figure be placed in the landscape? Should the figure be large or small? What about the other shapes in the landscape? What about color? Should I simplify the shapes? Should the painting be realistic or abstract? What about the edges? Hard or soft?

DECISIONS, DECISIONS

Realistically there is no limit to the possibilities. How does an artist make decisions? To come to a conclusion about what to paint, and how to handle things, an artist needs to understand the following:

- The way we see as humans, independent of cultural elements.
- How the introduction of cultural elements has an effect on the observer.

The way we see is critical to understanding how others will read your compositions. This "way of seeing" is common to all cultures. At its most basic, the eye is drawn to the area of greatest contrast in any visual field. (A painting is a visual field).

The most contrast gets the most attention from the viewer. The least contrast gets the least attention.

Consider **attention** as being the same as an emotional response.

CONTRAST AND SEEING

This abstract idea about contrast and seeing is essential to the human condition and is therefore essential in all of the arts. A small mark on a blank sheet of paper will draw the viewer's eye because it is different from its surroundings. The mark is a visual contrast against the quiet space surrounding it. This is a very simple example, however, the idea does hold true no matter how complicated or crowded the field of vision.

The viewer will notice the points of contrast in descending order from most to least.

The eye will always be drawn to and usually come to

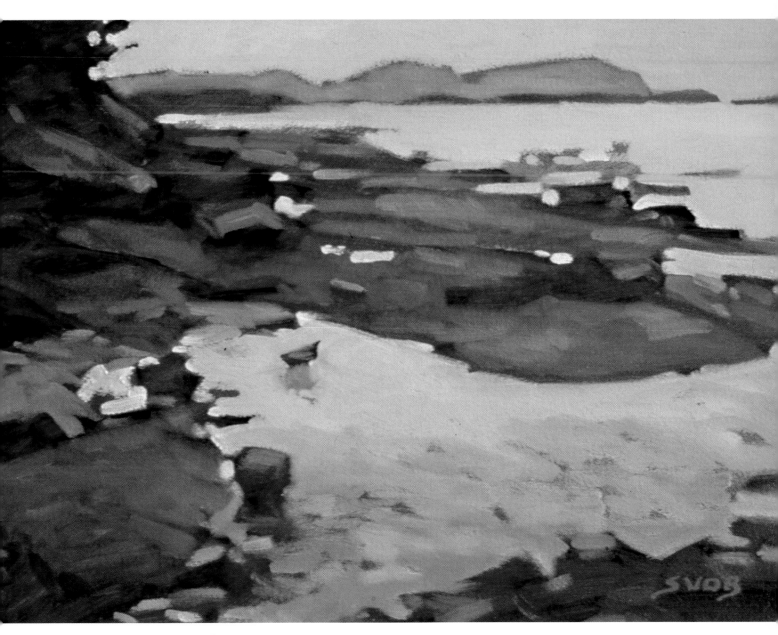

"Gabriola Shore", oil, 12 x 16" (31 x 41cm)
This composition is about shapes, color and depth.

FOCAL POINT
The primary contrast is in the lower left area.
The secondary is in the upper right. Lesser
points of interest balance out the pattern.

DESIGN PLANS
Shape, color, recession

Secondary contrast

Primary contrast

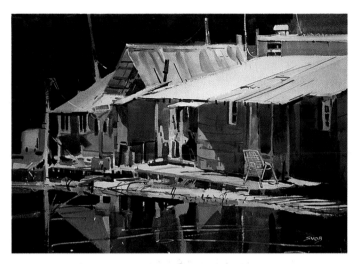

**"Rivers Inlet", watercolor,
15 x 21" (38 x 53cm)**

The composition of this watercolor painting went through several permutations. Originally there was a background of trees and sky, which wasn't working. When the background was painted over with the dark value the drama of the scene manifested. Quite often in a composition good things happen when the artist takes chances.

DESIGN PLAN
Drama

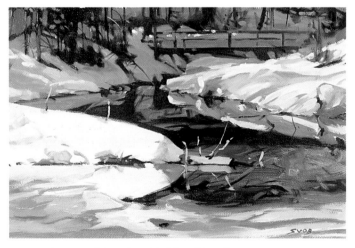

**"The Emerald Lake Bridge", oil,
18 x 24" (46 x 61cm)**

The warm sunlit log shape in the foreground helps form the focal point for this winter scene. The distant bridge draws the eye more than the standing trees because of its man-made regular shapes. Lesser areas of interest draw the eye along the water's edge to the reflections of the snow.

DESIGN PLANS
Contrast
Color

rest on the area of greatest contrast. This area of greatest contrast becomes the center of interest, the area of a painting that holds our interest above all else. However, it is not always one spot, it may be spread over a larger area.

Using this idea to help design your paintings will greatly simplify the decision-making process. By merely increasing or decreasing the amount of contrast in any area we can move the observer through the painting.

WHAT ARE YOU TRYING TO SAY?

It is generally important to have some sort of order of importance regarding the different points of interest in a painting — one area of secondary interest, followed by areas of tertiary interest, and so on, down the ranking. At the bottom, the points of least interest are the "foot soldiers" who, by numerous repetition, create a visual field for the more important characters to play on. As an artist you must decide who the general is and who will be the foot soliders. This decision is the most important, and often the most disconcerting one, to an artist.

Another analogy that may be helpful is to think of the center of interest in a painting as you would read it in a novel or see it in a movie. The crisis or climax is that point when you simply can't put the book down or wouldn't dare leave the movie, for whatever reason. This is the most exciting point. In a good work of art it is obvious when this point is reached. If it is not obvious to you as the artist, it will not be obvious to the observer. If the observer is confused about who the main characters are, or the setting isn't clear, or there isn't any crisis, you will lose them.

HOW TO INTRODUCE A THEME

Another area that needs consideration is the theme or setting of the work. This usually includes the minor points of interest, or foot soldiers, in their supporting role. These combine to create a theme (or setting) for the more important elements.

The theme, or harmony, of a painting can be created by any one of its visual elements.

A single color can give a painting harmony. Repetition of shapes will do the same. Light can be a theme. When artists refer to paintings having a certain lighting, say evening or midday, what they are really referring to is the combination of colors and values found in that light. Light, or the lack of it, ultimately determines color in all situations. (Value is identified by dilating our pupils so that we can generally see a full range of tones of light to dark in any light.)

So a painting can be given harmony with judicious use of color and value. Everything will look like it belongs.

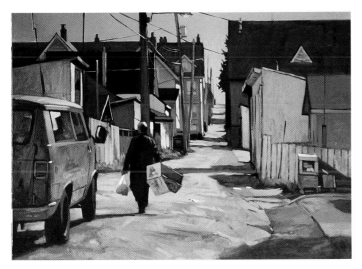

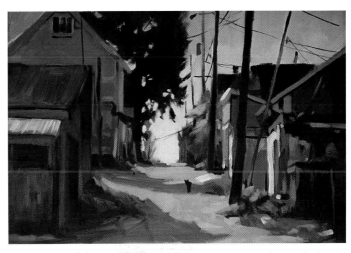

**"Back From The Market", oil,
30 x 40" (76 x 102cm)**
The angular shapes repeated throughout this painting — the buildings and fences — contrast with the more rounded figure and vehicle shapes.

FOCAL POINT
The figure becomes the focal point due to the strong value contrast but also due to the fact that the human eye will tend to look for other signs of life.

DESIGN PLANS
Repetition of shapes
Contrast

"Alley Cat", oil, 12 x 16" (31 x41cm)
The small light and dark shapes created by the dark tree against the yellow sky draw the viewer first. The eye then moves back and forth picking up area of contrast on the left and right. Finally we realize there is a black cat slowly meandering down the alley.

DESIGN PLANS
Shapes
Contrast

Repetition of shapes has the same effect. In this way individual trees become a forest. Put enough people together and you get a crowd. The shapes need not be realistic or abstract, it is repetition that creates the effect. A line drawing derives its harmony from the repetition of long thin shapes. The individual brushstrokes or texture found in impasto has the same effect of creating a harmony or theme of shapes in a painting without actually describing individual forms.

ORGANIZE THE VISUAL ELEMENTS
A simple listing of the visual elements available to any painter may be helpful in determining what to watch out for in the composition of a visual work. The most critical elements are shape and value. Value is merely how dark or light (devoid of all color) something is in comparison to something else. Shape is the element that tells us what something is.

Very often small, simple shapes combine to form larger independent shapes or create interdependent associations which make them read as something else. A wave, a hill, a mountain, a cloud in the sky, can all have the same shape. Put a person, or some other more definite object, in the picture and the shape, by association, becomes a hill, or a wave, and so on. Color can also help set the time of day or

night. An important aspect to remember is that color is affected by the amount of available light. More light equals more color, and vice versa.

CONSIDER EDGES AND TRANSITIONS
The three elements, value, shape and color are the most important elements artists have to design with. But, other important element to consider are edges and/or transitions. These edges, or changes in color and or value, can be as sharp as a knife or so gradual as to be almost imperceptible. Again the thing to keep in mind with all these elements is to remember that more contrast equals more attention.

Signs of life

The first thing the viewer will look for in a painting is signs of life.

If there is a person, we will look at the eyes first, then the face. Next, our attention is drawn to everyday man-made objects and, finally, to things which are man-made but unfamiliar.

UNDERSTAND THAT WE LOOK FOR SIGNS OF LIFE FIRST

The other aspect of composition and design which is not purely visual is the use of cultural elements to garner attention (remember attention equals emotional response). Cultural ideas vary greatly from one society to another, however, many things are common to all of us and can be used by the artist. In its purest form the amount of attention a cultural element will draw is determined by how familiar the viewer is with it. We are all trained to read symbols of one sort or another. Put a symbol, or language of some sort, in a painting and it will be noticed by the viewer, whether or not they can read that particular language. This happens because we are culturally conditioned to read, and is irrespective of the actual meaning of the words or their placement. Generally, there is a descending order of cultural attraction along the following lines:

The most important cultural elements are human references. We notice the eyes first, then the face, then the hands. Our attention is next drawn to everyday man-made objects and, finally, to things which are man-made but unfamiliar to that particular individual. Deciding how to make use of these cultural elements to create a composition or design is what differentiates one artist from another.

"Tangerine Lady", oil, 12 x 24" (31 x 61cm)
The orange colored kimono is the theme of the painting.

FOCAL POINT

The center of interest is formed by the face and hands, even though it is not the area of greatest contrast. The green pillow with its orange ribbon on her back provides the greatest visual contrast. Areas of lesser interest are the leaf design on the kimono, and the hairpieces.

DESIGN PLAN

Color

"Dappled Shore", oil, 24 x 30" (61 x 76cm)
The pattern of shapes formed by the trees branches against the sky is echoed by the shadows on the rocky outcrop. The hard edges on the rocks near the center of the image form the focal area of the design.

DESIGN PLANS

Pattern, Value, Color

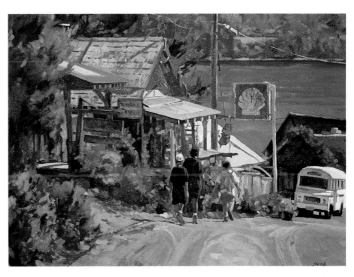

"Fraser Boats", oil, 12 x 16" (12 x 16cm)
Blue dominates this composition, creating a setting for the play of smaller, warmer shapes in the buoys, on the dock and on the boats. In this painting the brushstrokes help to harmonize the overall effect.

"Saltspring Afternoon", oil, 24 x 30" (61 x 76cm)
Figures were used in this design to create a focal point. Kids off on some Saturday afternoon mission. The Shell sign creates a stark color contrast against the deep blue of the water behind. The harder edges were saved for the area around the figures

DESIGN PLANS
Dominant color
Harmonious brushstrokes

DESIGN PLANS
Color contrast
Storytelling

TO SUM UP

The most important decisions are the initial ones. What will I paint? What am I trying to say about this subject? This is where we grasp the big picture in our mind, the "gestalt". This is where the elements the artist puts together are so integrated they constitute a complete design that is more than its parts. All the skills and techniques each individual artist possesses are brought to bear to create this composition. With any luck the mistakes of the past are not repeated. All the positive lessons garnered from hundreds and thousands of hours of practice come to the surface and are seamlessly knitted into a masterful piece of work, (or so we wish).

Ultimately, with practice and understanding, composition becomes a gut feeling. There is only a matter of greater or lesser satisfaction with a particular work on the part of the creator and the viewer.

DOES IT MATTER IF THE MESSAGE IS UNDERSTOOD?

It should be remembered that although you might believe your composition is successful and conveys a certain message, others may come to a completely different conclusion. This tendency will work both for and against, depending upon the particular piece. That a

viewer does not see what the artist intended does not make the composition a failure.

Very often when we communicate from one person to another the intent of the speaker (painter) is not what is heard (observed). In reality all artists speak first to themselves and then to an audience. To be a good, or great, artist one must speak as clearly and truthfully as possible. All artists have something to say but those who organize their elements (or language) to clearly outline their perceptions will have a deeper, more meaningful, connection with others.

However, sometimes those others may not be the group the artist first intended to connect with. Art is, as they say, a matter of taste. Just remember this when someone else comments as to the merits of your work, those who agree with you have "good taste", everyone who disagrees has "bad taste".

about the artist
Mike Svob lives in White Rock, British Columbia. He studied at the University of Western Ontario and has been dedicated to his art full time for 20 years. Mike has completed over two dozen large murals throughout North America and to date has had over 40 exhibitions. He is a past president of the Federation of Canadian Artists. He has won numerous awards and his paintings can be found in hundreds of private and corporate collections throughout the world. As a leading workshop instructor Mike believes that sharing knowledge provides only positive results.

ann zielinski

I develop preliminary patterns into powerful pictorial structures

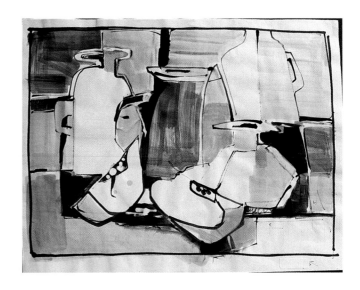

Study for "Orange with Ink Well"

I believe eye-catching paintings have good bones.

Let me explain my understanding of pictorial structure. It is like the human skeleton beneath the images on the picture plane. Think of structure as a pattern of values that underlies both positive and negative shapes. This pattern should extend to at least two of the picture edges. When the positives and the negatives and outside edges are tied together using a simple value pattern, the image is given strength.

Structure is a powerful tool that you can use to grab the viewer's attention and hold it.

Try this. Walk into an exhibition and quickly look at all the paintings. Note the images that hold your eye. Check them out for their structure. I bet those eye-catchers have good bones!

GETTING THE BONES

I prefer to make simple field sketches rather than use photos for reference at a later date. This allows me an

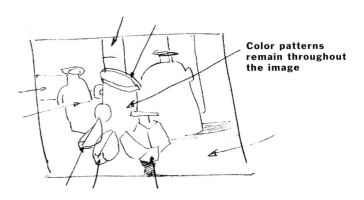

Color patterns remain throughout the image

Underlying color pattern
Here you can see how the color pattern is repeated throughout the image. The color pattern of a "start" often acts as a unifying factor in the finished painting

Design plans

- ✔ Make field sketches.
- ✔ Create several black and white structural patterns.
- ✔ Paint several spontaneous "starts".
- ✔ Match the "start" with the structural pattern.
- ✔ Allow a subject to suggest itself.
- ✔ Consider color, texture, pattern and value.
- ✔ Tie postive, negative and outside edges as a simple value pattern.
- ✔ Allow the underlying structure to show through.

Original sketch

"Ink Wells and Wedged Apple"
An example of working on a theme. This painting won an award at the
131st American Watercolor Society International Exhibition, New York.

**The black-and-white reproduction shows the
all-important structure**

**"Azurite Patina" — the finished painting won
bronze at the 129th AWS Exhibition in New York**

Working with "starts"

Illustrated below are a few examples of what I call "starts". These are all 16½ x 12" (42 x 30cm) in size. Paint was applied spontaneously, layer upon dry layer. Each one is unique and unrepeatable, and provides the creative "start". I then try to match these to my structure studies. The resulting combination of both images provides me with a final study which I continually refer to until the painting is finished.

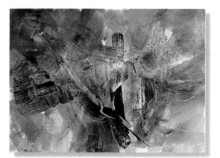

immediate first interpretation, the opportunity to edit on the spot, as well as time to observe and connect with the subject.

In the comfort of my studio, I work at rearranging the boundaries of some of the sketches by simplifying, emphasizing and exploring their lines and shapes.

I take a few of the most interesting ones and work out three or four possible structural patterns for each one. These are done rapidly using a mixture of felt pens, conté, ink and white gesso for adjustments.

I lay them all out on the floor for a critique. A few usually stand out because of their strong arrangement of values. All these studies are put aside. They may never be looked at again during the painting process but they have established certain critical forms to memory.

If they are used for the basis of a painting, they are considered guides only, changes are inevitable.

PAINTING BEGINS WITH "STARTS", AND "STARTS" ARE ALL ABOUT HAVING FUN

The paint is applied spontaneously. This is done layer upon dry layer. I have five or six sheets going at once. They are never forced or intellectualized. As the painter, I become the observer.

I love working on these improvizations — I work in a

art in the making — dragonfly

The "start"

I was fed up with a painting I had done previously of a dragonfly, so I painted over it with lots of darks but still allowed some of the first image to peek though. This gives a sense of history to the final painting.

Versions of the "Missions of Baja"

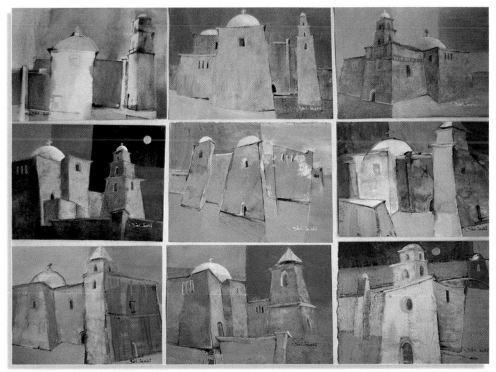

Working with themes

It helps to work on a general theme for several months. The subject will then possess the mind, making it easier to locate the subject within the color abstract pattern "starts". Repetition of a subject also leads to familiarity, which allows the artist to take liberties which lean towards greater abstraction. In this case, there is no need to refer to the studies because they would overly influence direction at this stage. It's a challenge to see how many ways one can say the same thing. When I get going the images roll out, 20, 30, 40 in a series.

Encouraging the idea to be born

I added paint at random without thinking of a subject and before long, the wretched dragonfly was sitting below the surface again seeming to want to get out. I had no intention of painting another dragonfly, I was sick of the old one, but there it was, so I went with it.

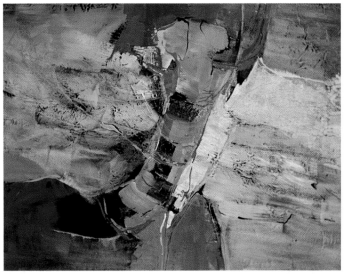

Body and head developed

Structural patterns
Here's a group of black and white structural patterns. They may never be looked at again during the painting process, but they have committed certain critical elements to memory.

Here my original study for "Green Pitcher and Wedged Apple" . . .

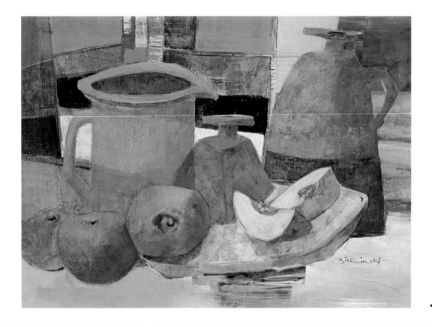

. . . and here's the finished painting.

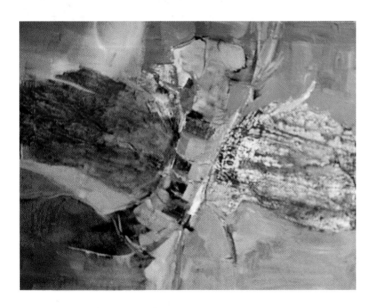

Right wing defined by blues and mauve blues

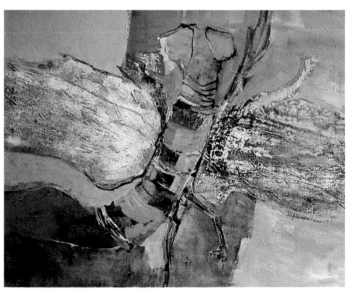

Warm/cool structure created
The left wing was lighted and textured with gesso. Yellow oranges were established on the left side to counterbalance all the cools on the right. On the lower left, light blue was added and mauve blue altered with a glaze.

state of suspended time. The paint is allowed full rein, one color leading to another, an adventure into the unknown! There must be no thought of where it is going or if it will ever lead to a "painting". Each one is unique and unrepeatable, which is a good beginning towards creativity.

One method that leads me to a finished painting is the evaluation of the "starts" and the structure studies. A match is made and the image is then molded into something resembling the study. The study is continually referred to throughout the process.

If the color and texture combination satisfies me but nothing comes to mind subject-wise, then they are put aside.

I have become so comfortable with the use of pictorial structure that it can be envisaged in my mind's eye or taken into account as the painting proceeds. If serious problems arise then I fall back and do some studies.

The color pattern of a "start" often acts as a unifying factor in the finished painting, I allow its color and texture to remain in varying degrees in areas of the main subject as well as in the background. Semi opaque overlays, transparent glazes and opaque passages achieve variation.

"Starts" can be infinite but eventually I have to limit the fun. As the color and texture develops, I most often find the subject within the paint patterns.

The spontaneous "start" mode remains as I work towards a more realistic image or towards an abstract but at this stage I have a little more of the upper hand. I am frequently out of control and, of course, run into lots of trouble. I think I like to create problems for the love of solving them. If the work begins to look labored or inferior, drastic action is taken. I destroy the offending painting with wild swathes of paint. Most satisfying! What comes out of this spent energy is often an excellent painting.

about the artist

Ann Zielinski was raised in the interior town of Trail, British Columbia, Canada. She graduated from Vancouver General Hospital as a laboratory technician. During a solo journey around the world, Ann stopped in Paris, saw the impressionist works, and that was the start of her desire to paint.

In 1972 she and her husband moved to Hornby Island, a place inhabited by artists and intellectuals. After doing weaving, she began painting 15 years ago and hasn't looked back since.

Ann explores and experiments with all water based media, and now teaches her methods. She has won a Bronze Medal of Honor at the American Watercolor Society annual exhibition in New York; she has two awards from the Knickerbocker National Show in Washington, DC; she won the Jules Kulburg Award at the NWWS International Show in Seattle, WA; came first at the Federation of Canadian Artists Oil and Acrylic Show in Vancouver and came second at the International Napa Valley Store Open Competition in California.

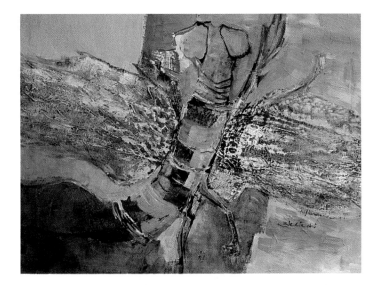

Final adjustments made
Blue is carried through part of the left wing.

Finishing touches

biographies

Donna Baspaly has been exhibiting publicly since 1979 and her work has received several awards. She is a respected juror for prestigious art prizes. Donna has been a signature member of the Federation of Canadian Artists since 1997. She has participated in many group exhibitions with the Canadian International Festival for the Arts. She also collaborated with Canadian Airlines to help raise money for AIDS research. Her work is in many private and corporate collections in Canada and internationally.

Robert Bateman is an officer of the Order of Canada, he was awarded the Golden Plate from the American Academy of Achievement, and has been named one of the 20th Century's Champions of Conservation by the US National Audubon Society. He has been the subject of several films and three books of his art have made publishing history. Two schools in Canada have been named after him. His work is held in many public and private collections and several art museums. His art reflects his commitment to ecology and preservation.

Alessandra Bitelli was born in Italy and arrived in Canada in 1977. She is a Senior member of the Federation of Canadian Artists. She served as President of the Federation from 1997 to 1999. In 1989, Alessandra was elected a signature member (CSPWC) of the Canadian Society of Painters in Watercolor. One of her paintings is now part of the CSPWC Diploma Collection. She has had 12 solo shows and participated in numerous international exhibitions, including the American Watercolor Society, National Watercolor Society and Royal Institute of Painters in Watercolours, London. Her awards include: AWS High Winds Medal, New York; CSPWC Trillium Workshops Award, Montreal; FCA Gold and Bronze Medals, Vancouver.

Alan J Bruce is an elected signature member and regional representative for the National Watercolor Society (NWS), Los Angeles, California, USA. His work has been published in several compendiums of Canadian artists, and has been hung in many prestigious exhibitions, including the 70th Annual National Watercolor Society Show, the Federation of Canadian Artists show, the Musso de la Acuarela Mexicana, Mexico. Alan was a featured artist in *International Artist* magazine. He currently lives in Victoria, BC Canada.

Don Farrell was born in Canada. He has received numerous awards including the London Royal Institute of Painters in Water Colours RI Medal. He is a full member of the Royal Institute, a member of The Royal Society of British Artists and is a signature member of the Federation of Canadian Artists. His work hangs in HRH the Prince of Wales collection, as well as many private collections around the world. He is listed in "Who's Who in Art in Britain". Don regularly takes part in the annual exhibitions of the RI and RSBA at the Mall Gallery in London, and he is represented by galleries in Britain and Canada.

Brian R. Johnson lives in Canada. He graduated with distinction from the Art Center in Los Angeles and is one of Canada's most highly respected artists. He is a member of the Royal Institute of Painters in Watercolours (London). He and his wife, Jean, live in Victoria, BC, Canada.

Peter Folkes was born in England and studied at the West of England College of Art, Bristol. He served in the Royal Corps of Signals during WWII. Peter was the Head of the Department of Fine Art, Southampton Institute of Higher Education and retired in 1989 to paint full time. He is an Academician of the Royal West of England Academy in 1960, and is currently vice president of the Royal Institute of Painters in Water Colour. He has had 17 solo shows in the UK, as well as two in New York. His paintings are in many private collections including the Arts Council of Great Britain and the Royal West of England Academy.

Britton Francis was born in Canada and graduated from the Alberta College of Art. He has a postgraduate scholarship from the Institute De Allende, Mexico. His work can be found in many collections including the Government of Canada, the British Columbia Government and the Mendal Public Art Museum. He has received many awards and has had over 40 group and solo exhibitions across Canada. His work has also been exhibited in the USA, London and Australia. He is listed in the "Who's Who" of British Columbia, Canada. He is on the board of governors and is a signature member of the Federation of Canadian Artists.

Robert Genn was born in Canada. He attended the University of Victoria, the University of British Columbia and the Art Center School in Los Angeles, California. His autobiographical book "In Praise of Painting" provides an insight into the progress and trials of a Canadian painter. Other publications include "The Dreamway" and "The Painter's Keys". His paintings and reproductions are found in major collections throughout North America and Europe. His work has been featured in *International Artist* magazine. Robert is also one of *International Artist* magazine's International Painting Workshop Vacation teachers.

Kiff Holland was born in South Africa and now lives in Canada. He studied art at the University of Witwatersrand and the Johannesburg School of Art. Kiff is a signature member of the American Watercolor Society. He won first prize in the 1993 Societe Canadienne de L'Aquarelle in Montreal, and was recipient of the annual Gold Medal Award from the Federation of Canadian Artists in the same year. Kiff is a past president and senior member of the FCA. He teaches in the Design Illustration department of Capilano College and has conducted workshops in France as well as Canada and the USA. In addition, his work has been exhibited in Britain, South Africa, Mexico and Australia.

Tom Huntley studied commercial art at the Vancouver School of Art and was an apprentice with a lithographic artist. He became Advertising Manager of CKNW Radio, he spent 18 years as Vice President and Creative Director of Foster, Young, Ross, Anthony and later became Marketing Consultant to Woodward's Food Floors. Tom is on the board of the Federation of Canadian Artists. He has taught many workshops in Canada. He covers a wide variety of subject matter with particular emphasis on portraits, for which he has received many commissions. His work is held in private and corporate collections in Canada and internationally.

Neil Patterson studied at the University of Calgary and the Scottsdale Artists' School. He is a member of the Salmagundi Club, New York, NY; a signature member of the Alberta Society of Artists; Federation of Canadian Artists and he was the first Canadian to be awarded master signature membership in the Oil Painters of America. He has distinguished himself in several "Arts for the Parks" competitions. In May 1999 he took part in the Carmel Art Festival Plein Air Competition held at the Pitzer Gallery in Carmel. Collections holding Neil's work are too extensive to list. His work has also been featured in *International Artist* magazine.

Myfanwy Pavelic has received many awards including the Order of Canada, Membership of the Royal Canadian Academy and an Honorary Doctorate of Fine Arts from the University of Victoria, where the main collection of her work is now held. Myfanwy is one of Canada's foremost painters and her portraits grace several important collections. Her notable portraits include Pierre Trudeau and Yehudi Menuhin, which hangs in the National Portrait Gallery in London. At the age of 18 she was encouraged to show her work to the prestigious American Portrait Academy.

Nancy Slaght has had a colorful life, having tried a number of different careers. She finally enrolled in the Victoria College of Art. She believed that Canada's west coast, which seemed a place where abnormal people appeared normal, might become her ideal home. After two years, Nancy was ready to snap her brushes, burn her canvases and withdraw her tuition for the following year. But then she opened a cheap box of chalk pastels. Their alluring ability to function as both drawing and painting medium hooked her completely, and she set her sights on becoming a professional artist. In addition to creating her gallery work, Nancy is now back at Victoria College of Art, this time as a teacher of pastel drawing and painting. She's represented by Winchester Galleries in Victoria and the Quest-Avens Gallery in Canmore, Alberta.

Mike Svob lives in White Rock, British Columbia. He studied at the University of Western Ontario. Mike has completed over two dozen large murals throughout North America and to date has had over 40 exhibitions. He is a past president of the Federation of Canadian Artists. He has won numerous awards and his paintings can be found in hundreds of private and corporate collections throughout the world.

Ann Zielinski was raised in Canada. She graduated from Vancouver General Hospital as a laboratory technician. In 1972 she and her husband moved to Hornby Island. After trying weaving, she began painting 15 years ago and hasn't looked back since. Ann has won a Bronze Medal of Honor at the American Watercolor Society annual exhibition in New York; she has two awards from the Knickerbocker National Show in Washington, DC; she won the Jules Kulburg Award at the NWWS International Show in Seattle, WA; came first at the Federation of Canadian Artists Oil and Acrylic Show in Vancouver and came second at the International Napa Valley Store Open Competition in California.